TO _____

FROM _____

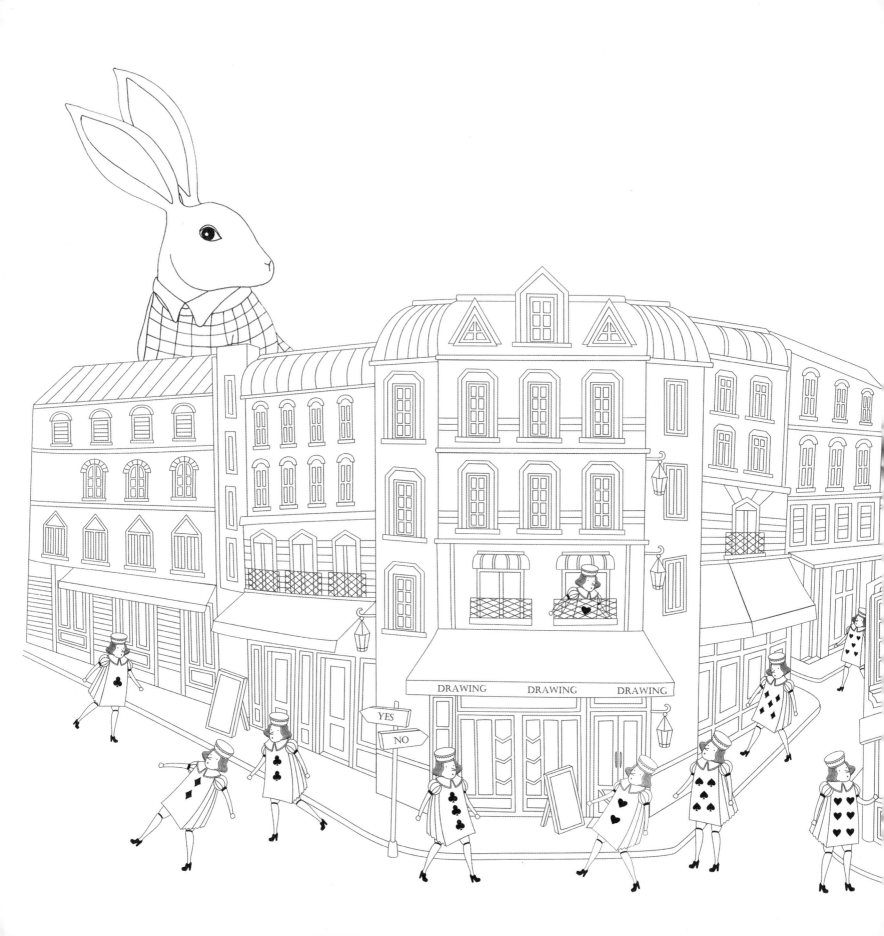

WONDERLAND

A COLORING BOOK INSPIRED BY ALICE'S ADVENTURES

AMILY SHEN

WATSON-GUPTILL PUBLICATIONS
Berkeley

Dedicated to you,
who loves to imagine, loves to draw.

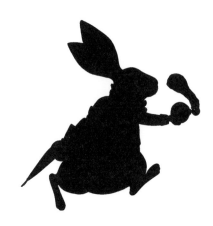

Trade Paperback ISBN: 978-0-399-57846-5

Printed in China

Design by Ashley Lima

10 9 8 7 6 5 4 3 2 1

First American Edition

Do you know Alice's story?
Do you draw pictures in your head while reading?
Strange conversations with a strange cast . . .
has the story been transformed?
If you too jumped down the rabbit hole,
who would you meet?
What colors would you encounter?
Take up your colored pencils,
and together let's make a book.
Read with your colored pencils,
and give Alice a new adventure.

My name is _____.

When the sun is warm, I take a sketchbook and my colored pencils to a café. I fill my sketchbook with the colors that best suit my day, starting with the free lines that will be fleshed out with color. This is my favorite way to pass the time, quiet in vibrant creation.

Draw something in the notebook!

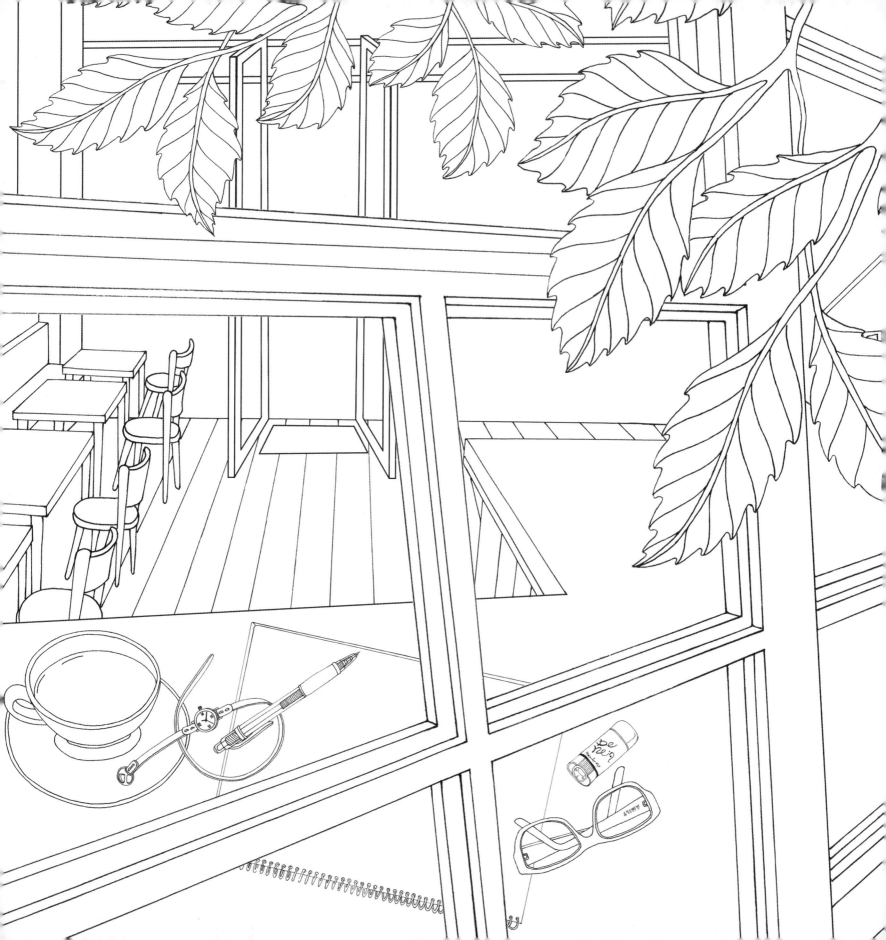

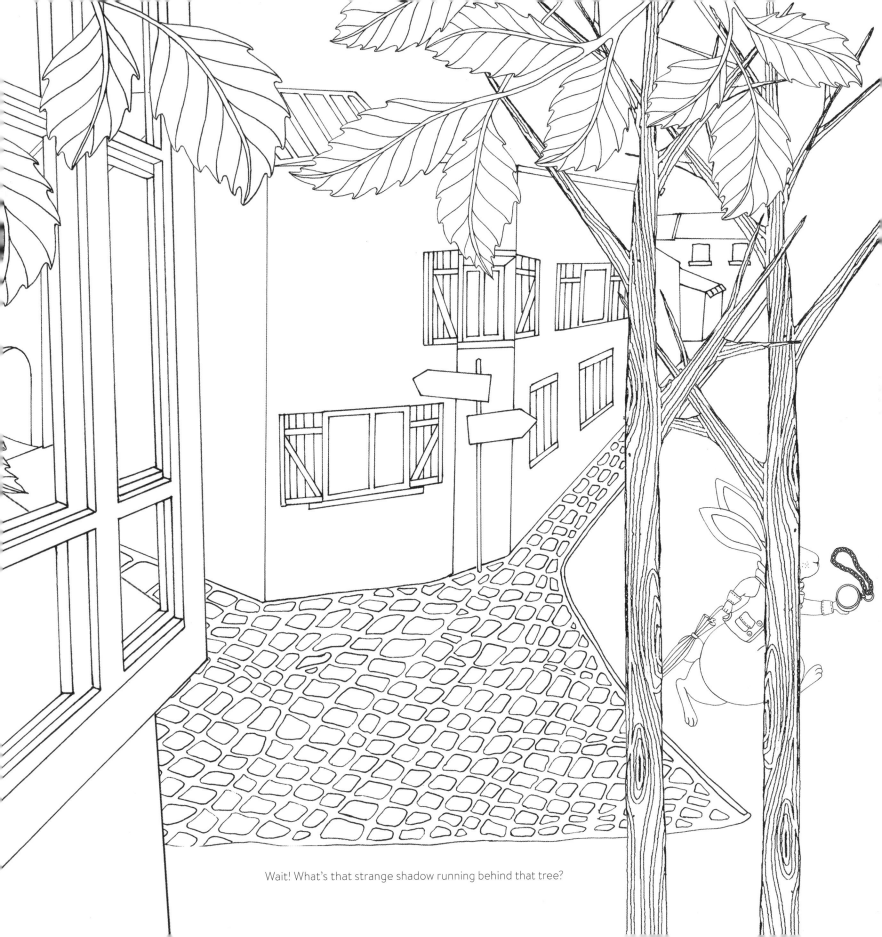

Wait! What's that strange shadow running behind that tree?

1

DOWN THE RABBIT HOLE

Look! Is that a rabbit running? Gentlemanly in a starched suit, pocket watch in hand, he mutters under his breath, looking flustered. Is he on his way to a party?

He slips between the flowers and disappears through a magical door. I follow after him and suddenly, down I tumble, strange objects swirling around me . . . until I land with a thump in a mysterious room.

I look around, but there's no sign of the rabbit. I see a small door, and beyond it a beautiful garden. But how do I get out? Perhaps this potion will help me? I take a sip.

But now I've shrunk so small, I can no longer reach the key on the table. Help! Should I eat this piece of cake?

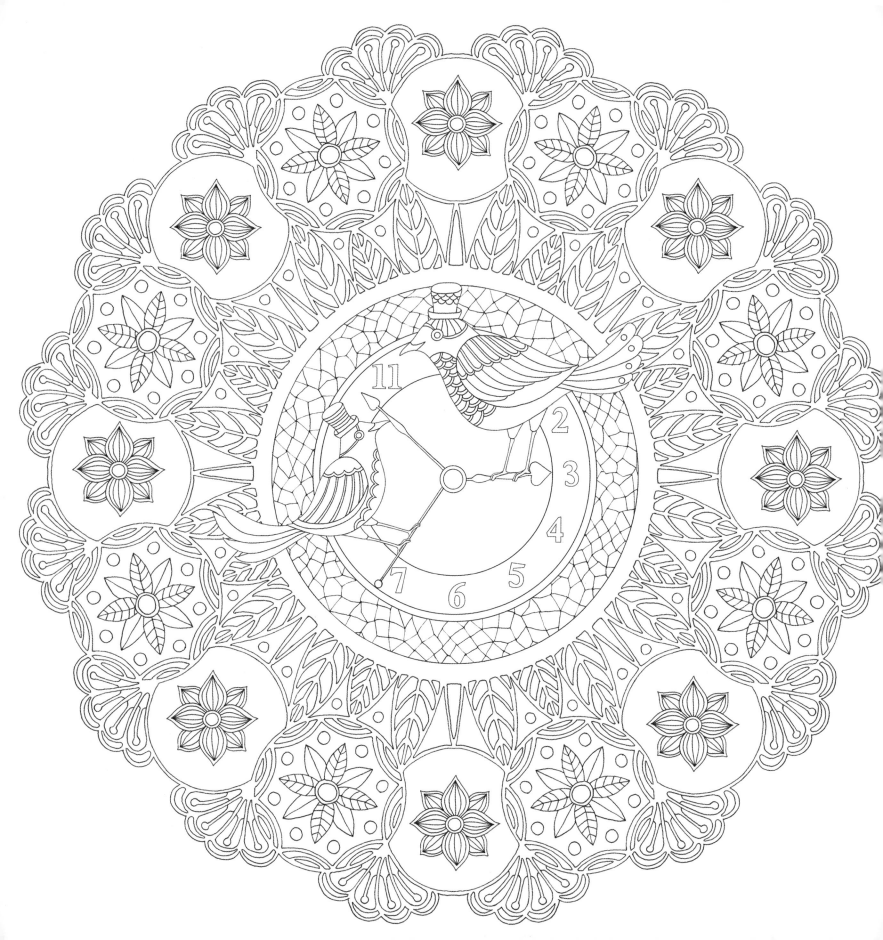

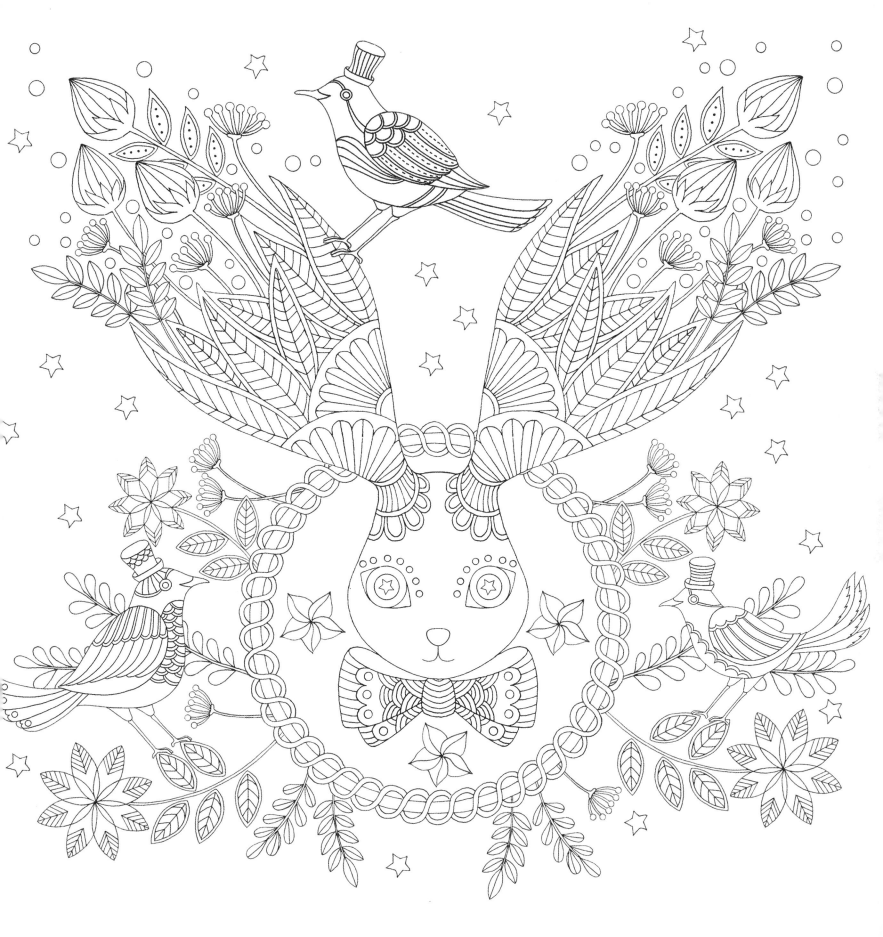

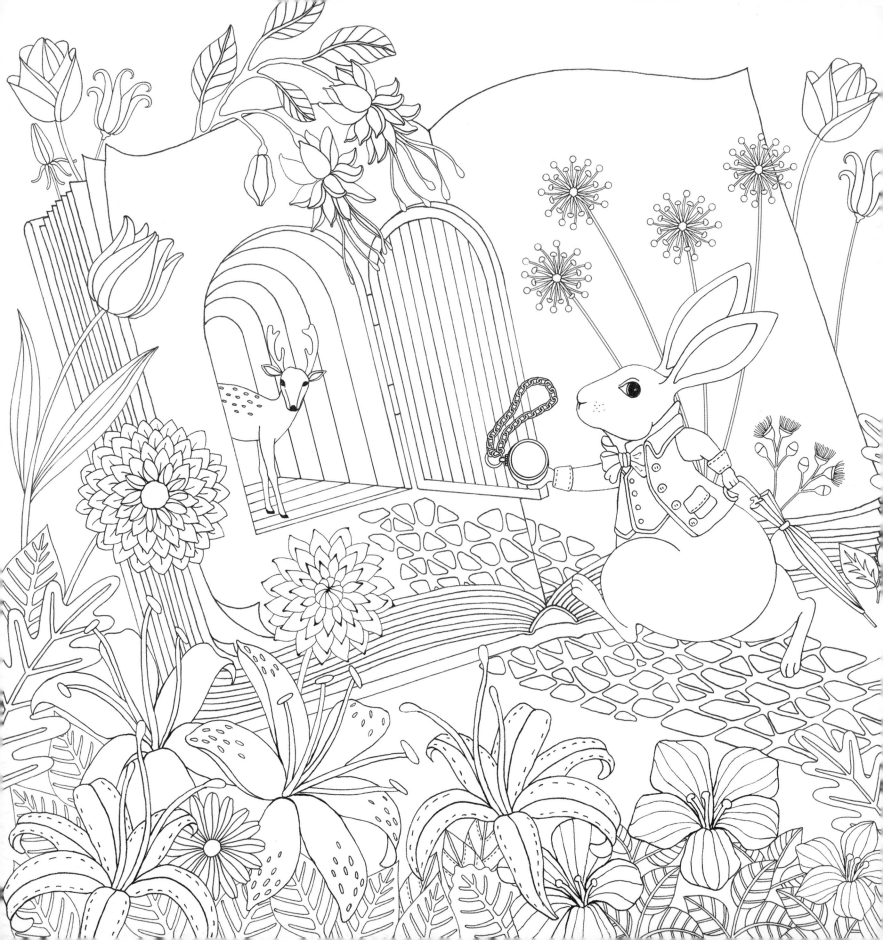

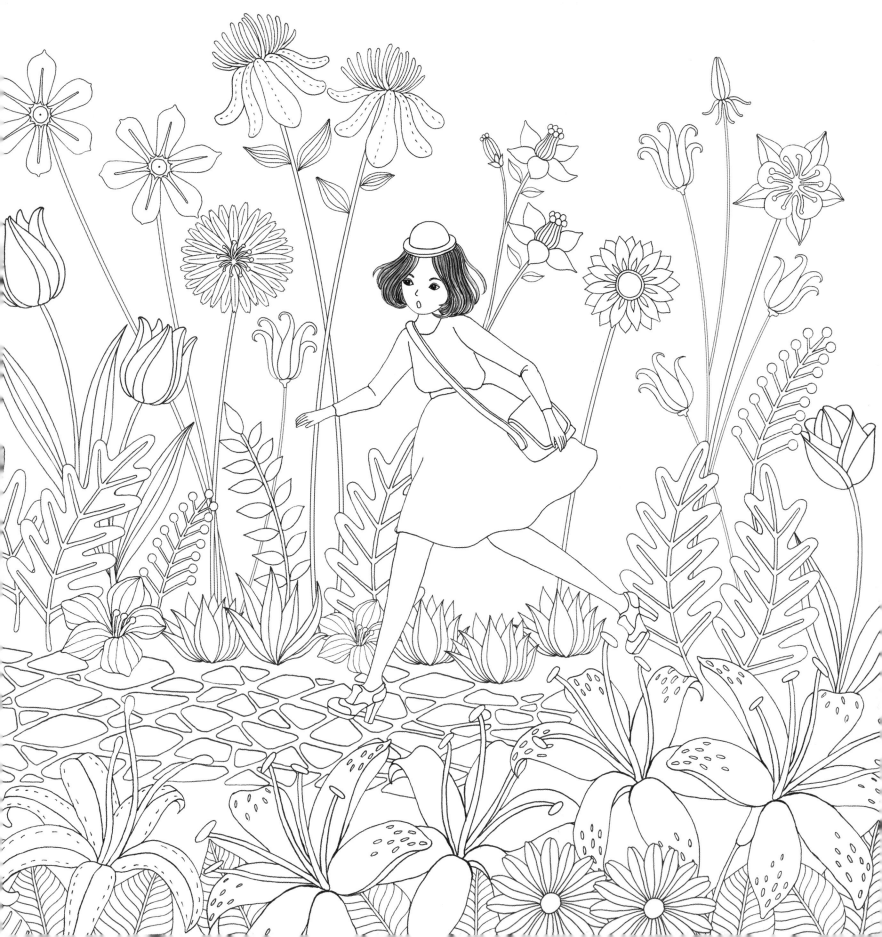

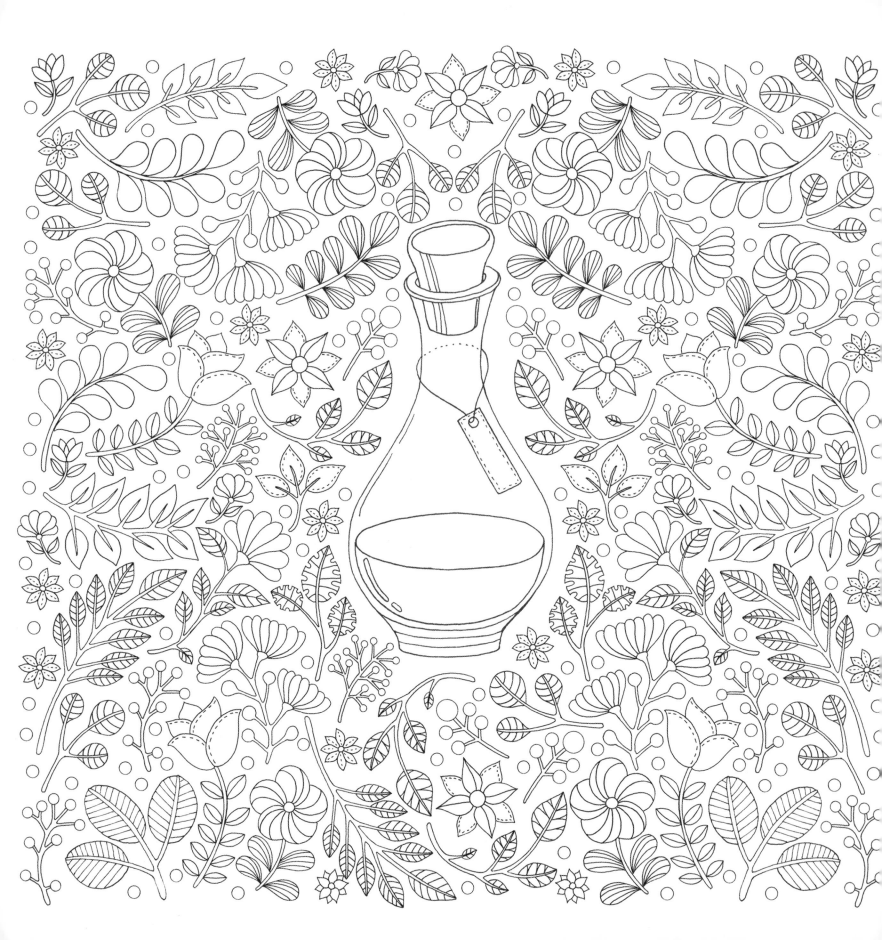

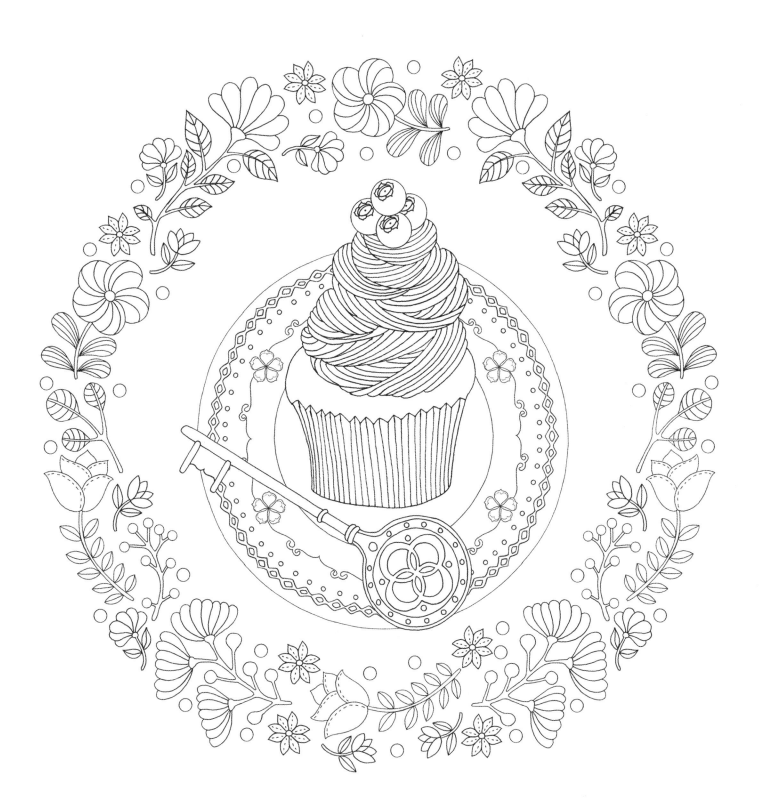

2

A MOST STRANGE RACE

I ate the cake and now I am giant. What should I do? My head is pressing
against the ceiling!

I melt into sobs—I can't help it—tears flowing out of me as if from a tap.
As I cry, I start to shrink again.

Oh no! Now I'm tiny, floating in an ocean. I shouldn't have cried so many tears!

Swimming, a mouse bobs past me, then various strange-looking birds. Where
are they going?

We climb onto land but everyone's soaking. Someone suggests,
"A race! To see who can get dry first!" We start running in circles.
But who is going to win? Who knows? Maybe everyone's a winner.

The Dodo wants a prize from me. I find some sweets in my
bag, enough for everyone. They eat and leave happy. A most
bizarre competition.

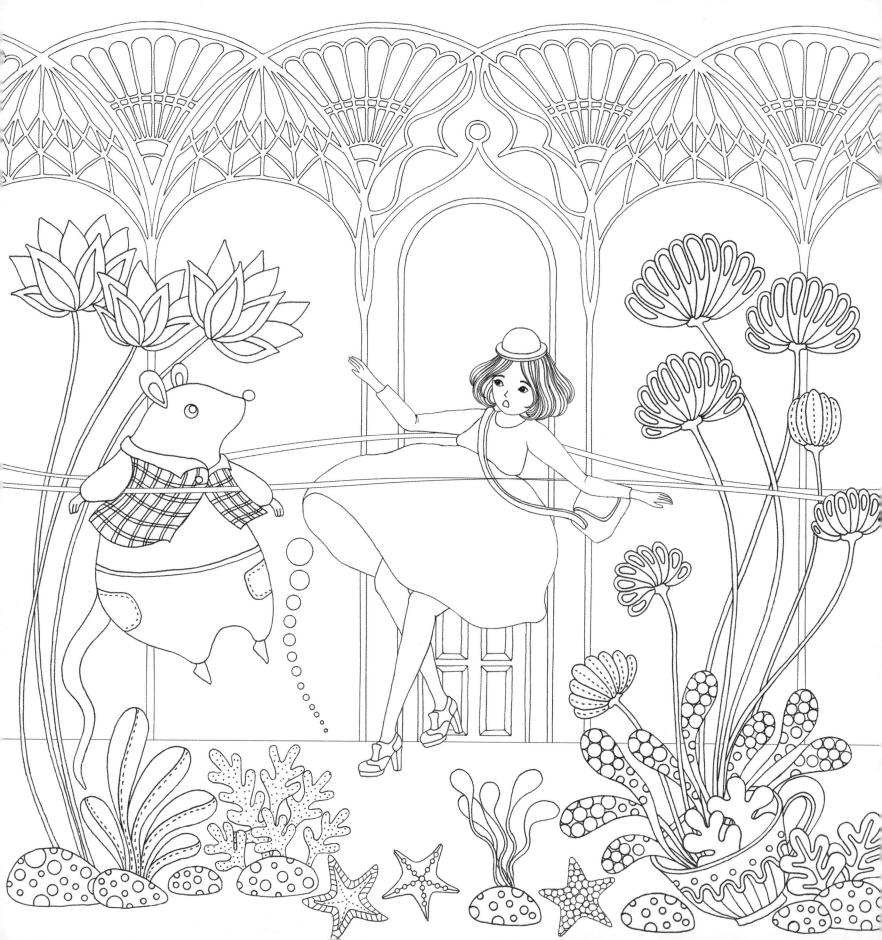

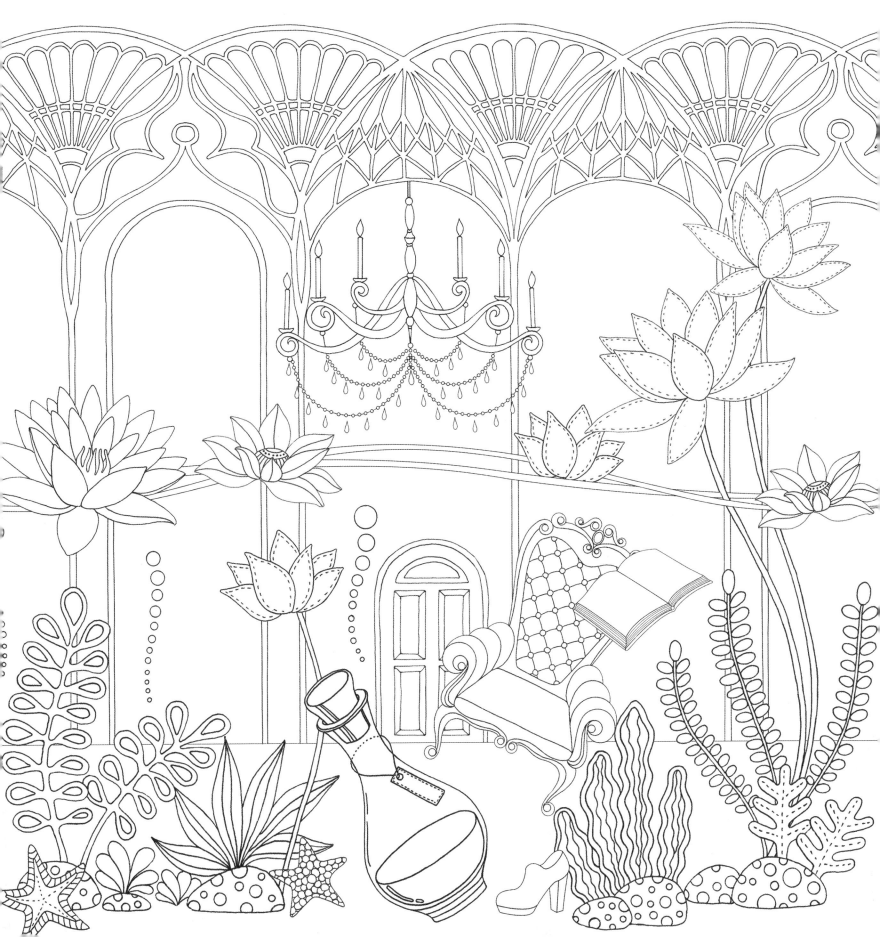

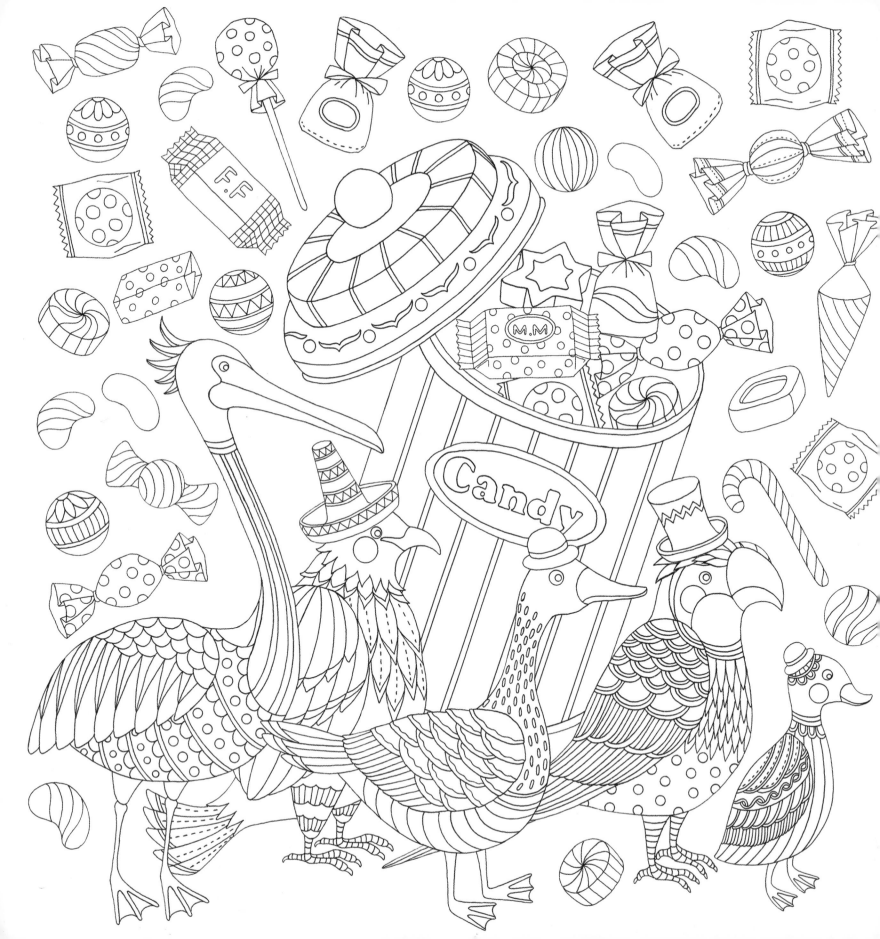

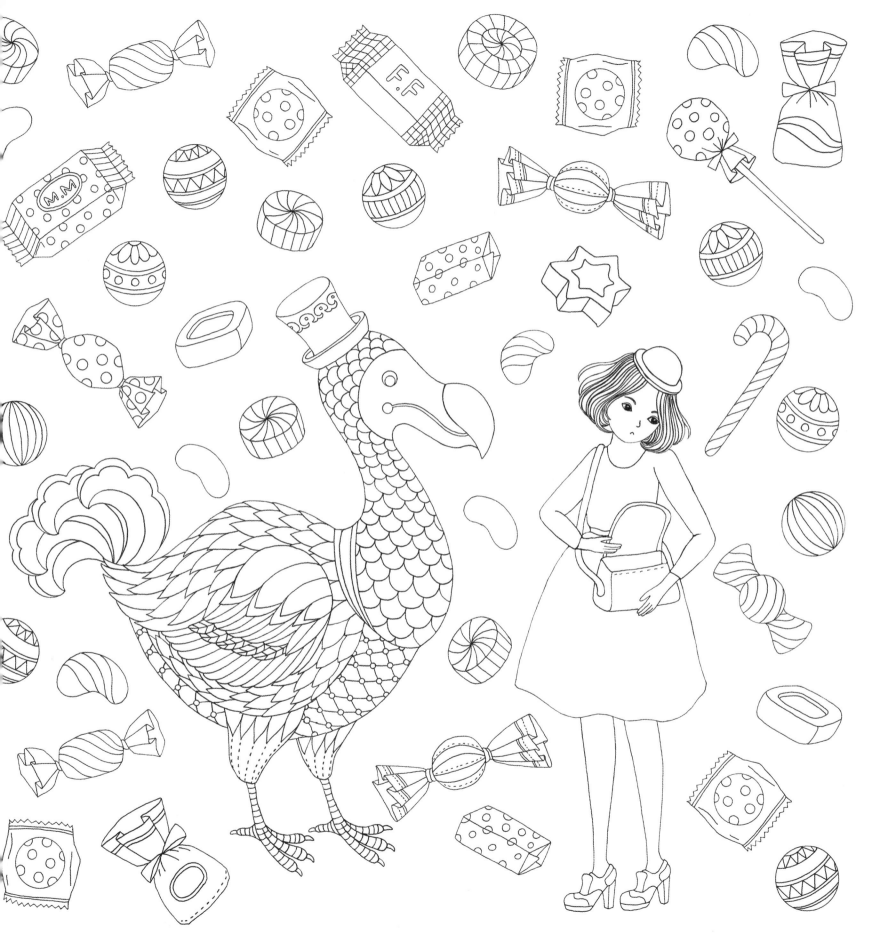

3

THE PLAYING CARD
IS GETTING AWAY!

I enter a city, home to a pack of living cards. I see one, and he runs around
a familiar corner, looking nervous, as if he's trying to escape from someone.

He sees me and wants to swap the scroll in his hand for my bag. Curiosity gets
the better of me—I want to know what it says! With my bag slung around his neck,
the playing card runs away. Thank goodness he didn't realize it was wet!

I assumed no one witnessed our exchange. . . . But could that be someone
watching from the café across the street?

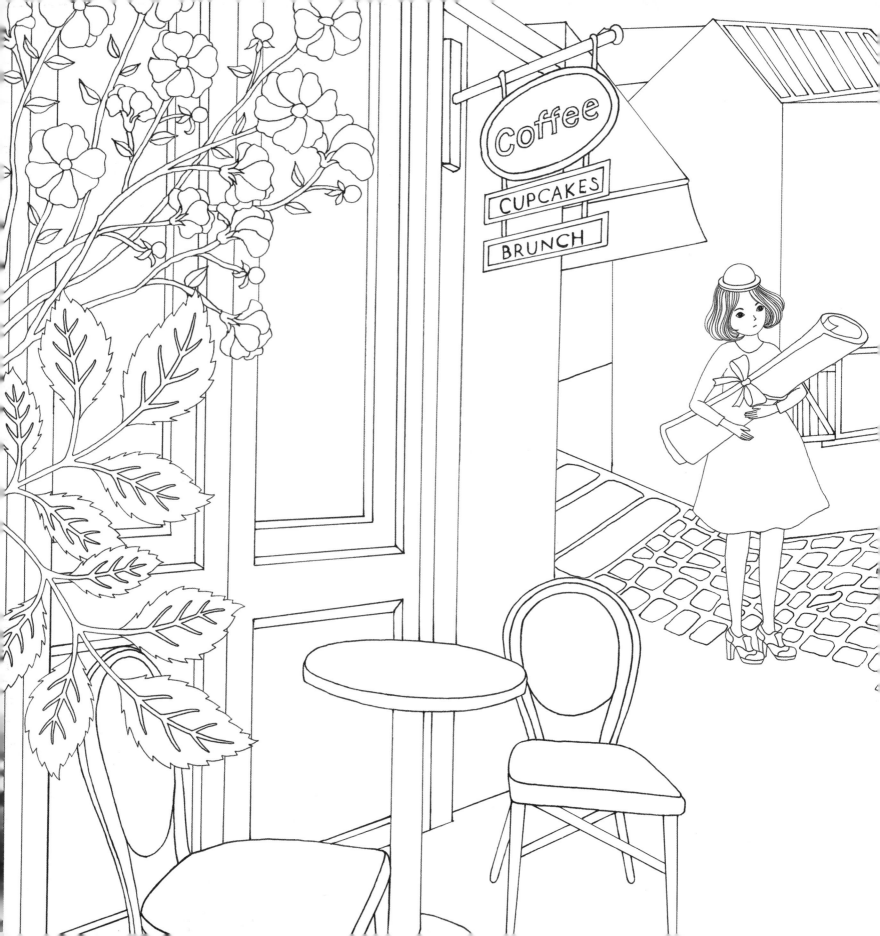

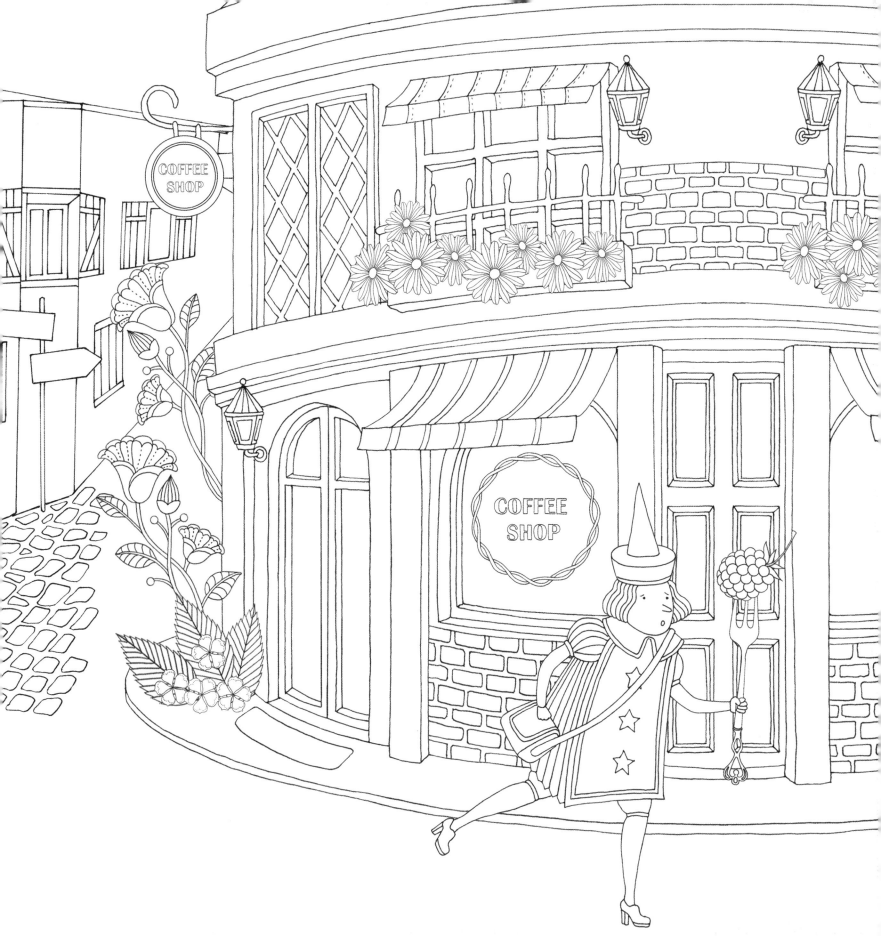

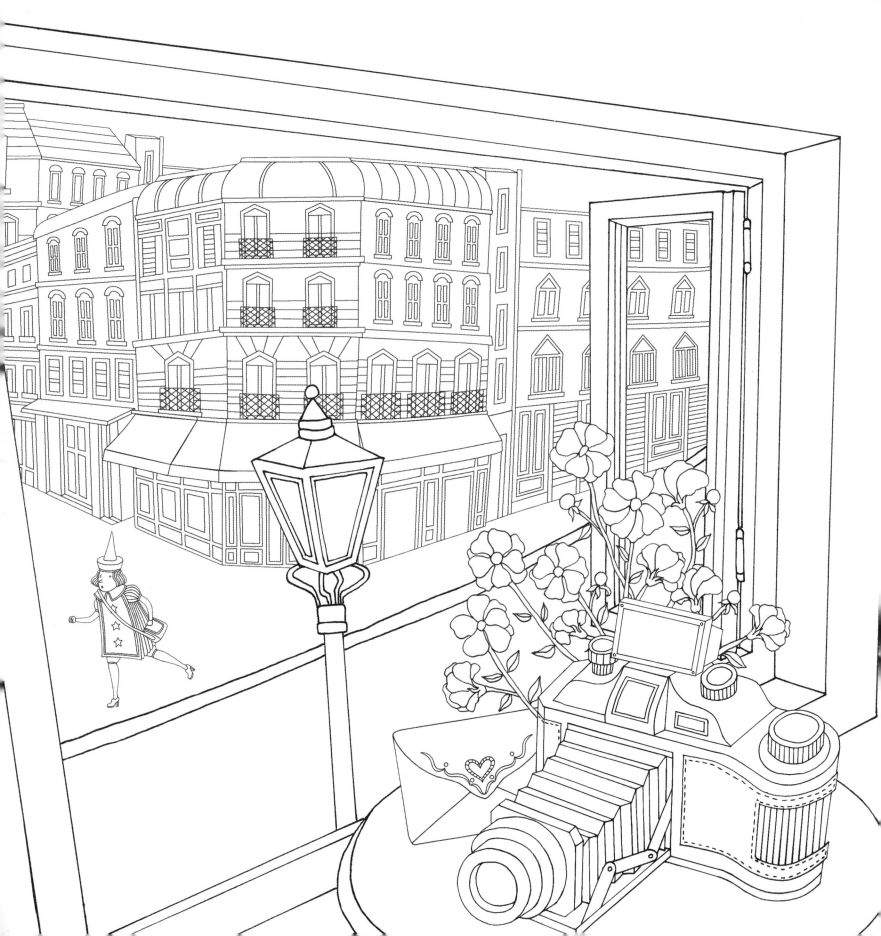

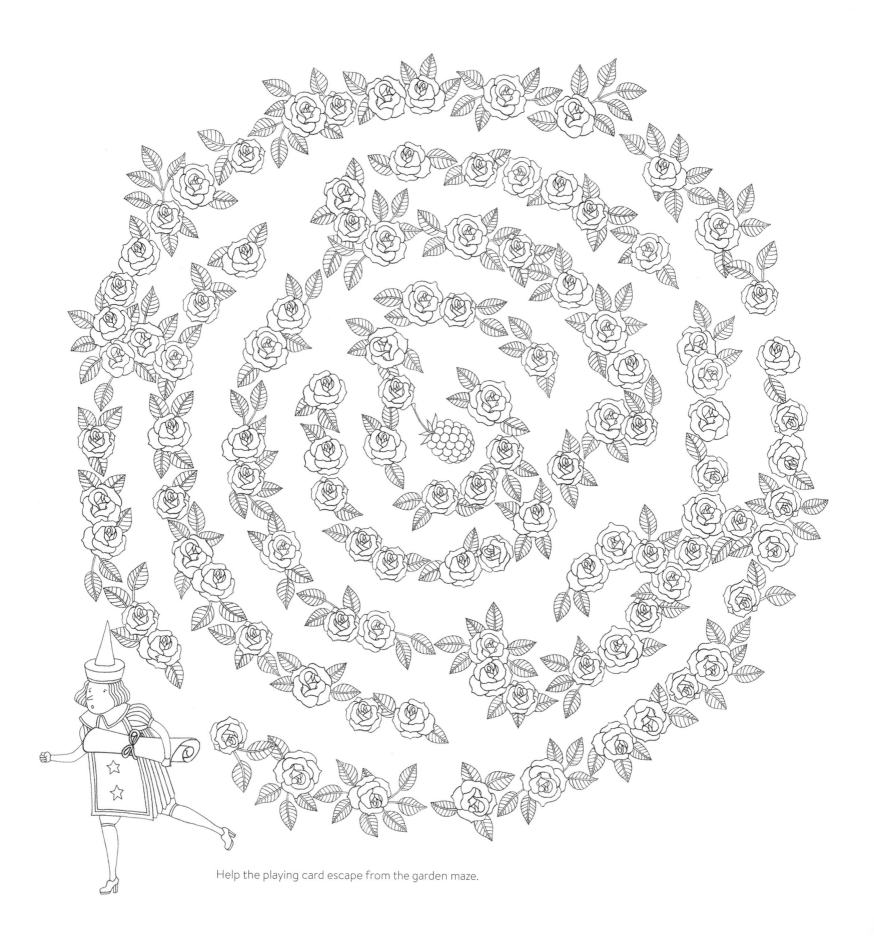

Help the playing card escape from the garden maze.

THE SCROLL

The playing card's scroll contains five puzzles. Find the answers as you go through this book.

A: The White Rabbit has lost two fans and four pairs of gloves. Help him find them! He must have left them in his house, or out on his travels.

B: The playing cards have a strict uniform, but one of them has lost his shoe. Who is it? And where has he lost it?

C: The Queen of Hearts has sent out four invitations. Can you find them?

D: The deer of Mushroom Forest love to run around. How many deer can you find?

E: Can the White Rabbit find the tart-eating culprit? Can you work it out?

4

THE WHITE RABBIT'S HOUSE
AND THE ROCK CAKES

I leave the town and come upon the White Rabbit's house, enveloped by foliage. The White Rabbit's house is so tidy, with a lovely fireplace and chairs around a small table.

What would happen if I drank from this? I can't stop myself, I take a sip. Oh my! I'm growing! I lie down and bend my head as it presses against the ceiling. How terrible!

The White Rabbit spots me and cries out with fright, throwing rocks at me, trying to get me out. They hit my face and I expect them to hurt, but instead they turn into soft, fluffy cakes. I eat one and shrink smaller and smaller, smaller and smaller.

I run out the door and into the forest, before Mr. Rabbit can catch me. . . .

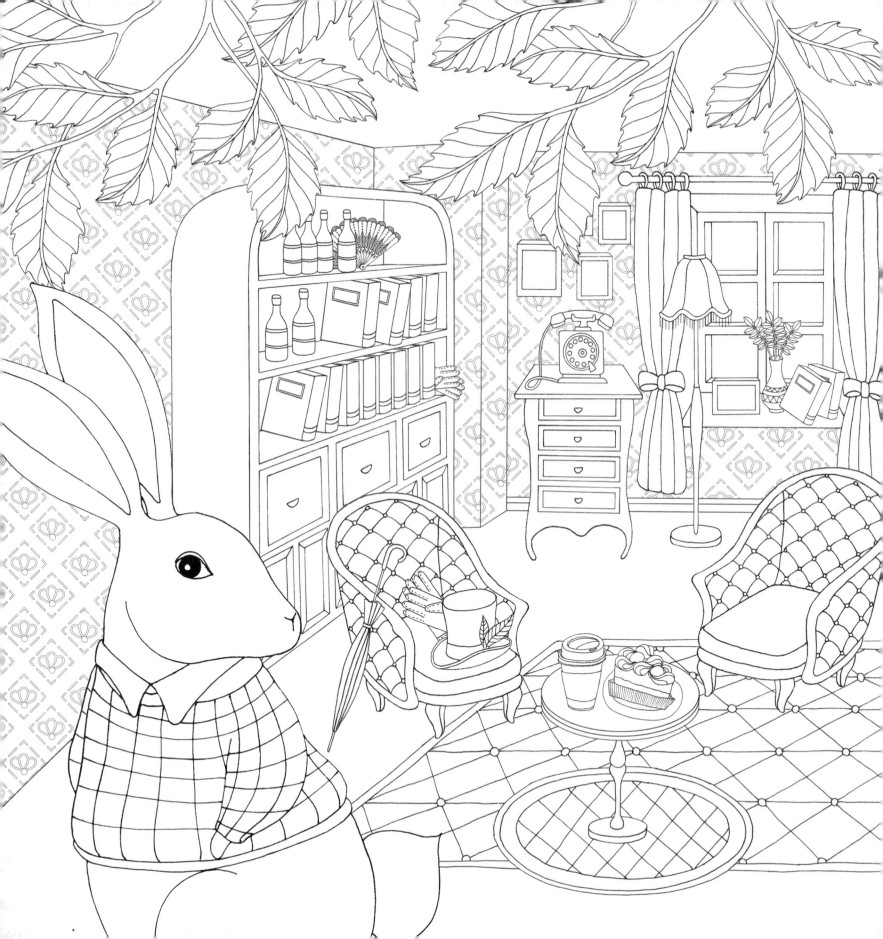

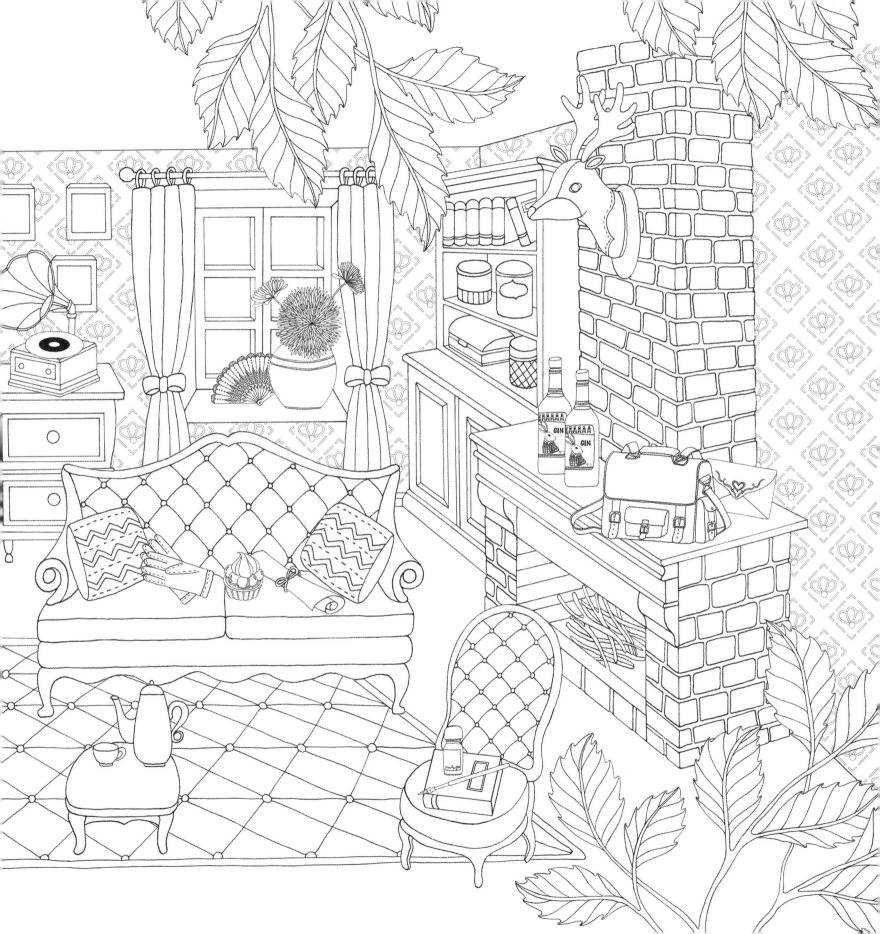

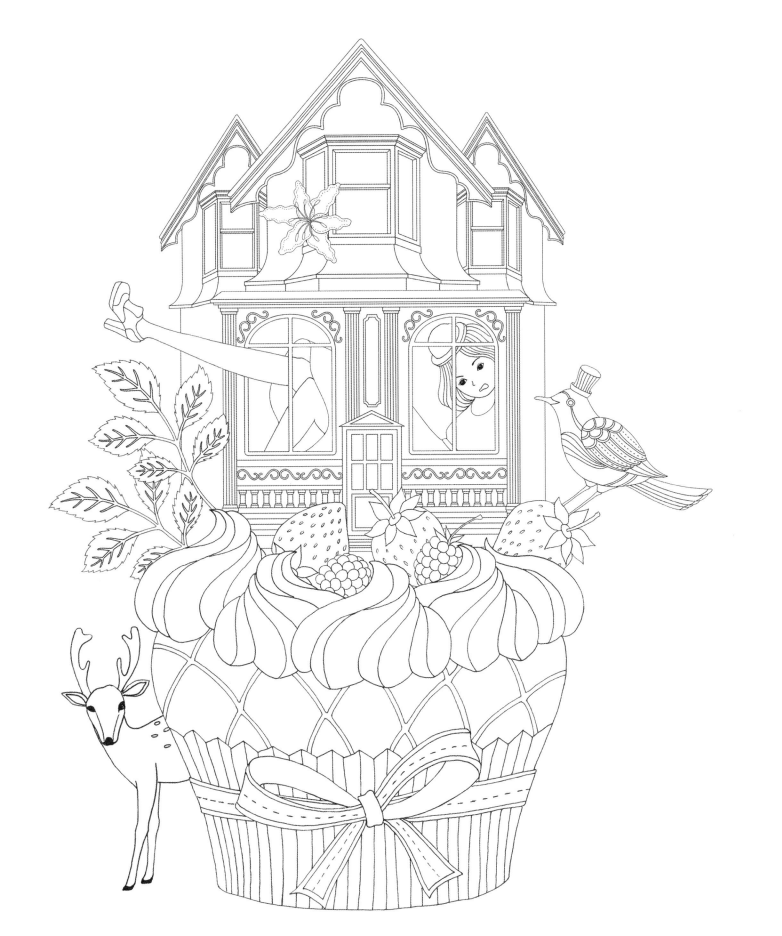

5

THE TEAHOUSE IN THE
MUSHROOM FOREST

In a panic, I run into the Mushroom Forest, where I come upon a teahouse encircled by deer. I'm thirsty and fancy some tea, but I don't want to disturb them.

They collect in a huddle, whispering. I forget any thoughts of refreshment. A pigeon sitting in the branches above doesn't seem too welcoming. She stares at me, scared I'll steal her eggs. But I don't want her eggs!

I notice that the sky is filled with butterflies, watching me as I continue on through the forest.

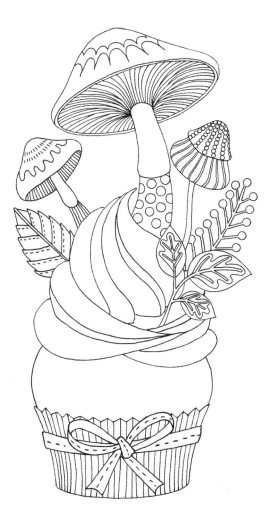

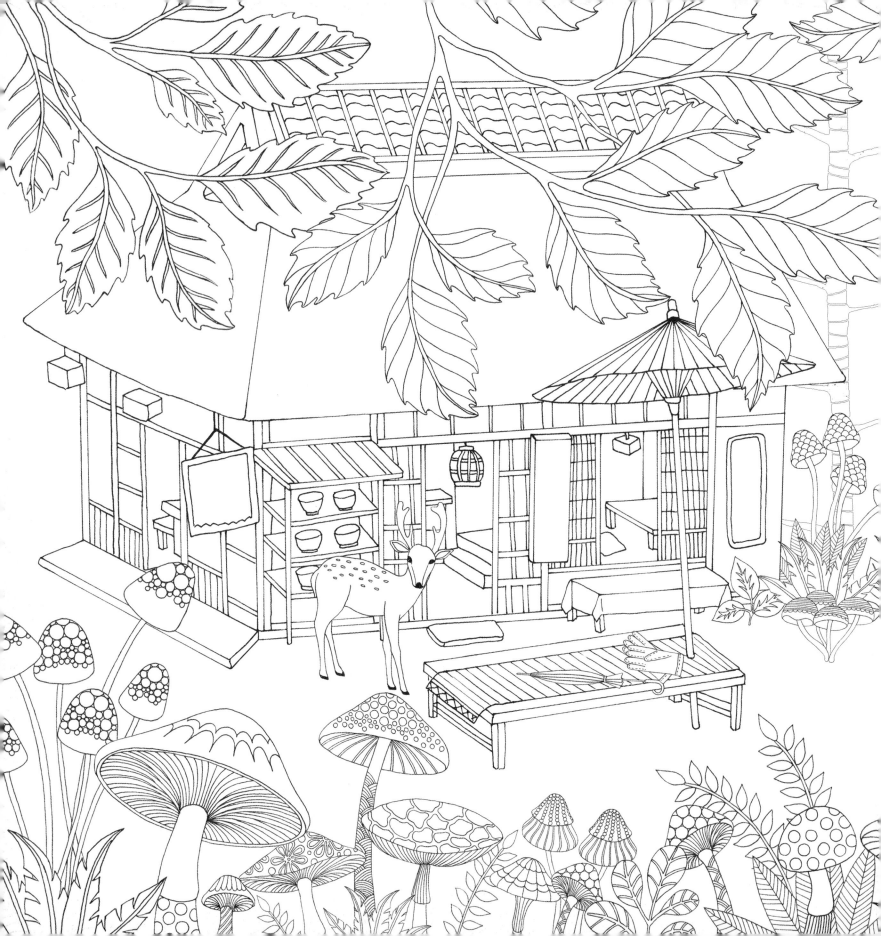

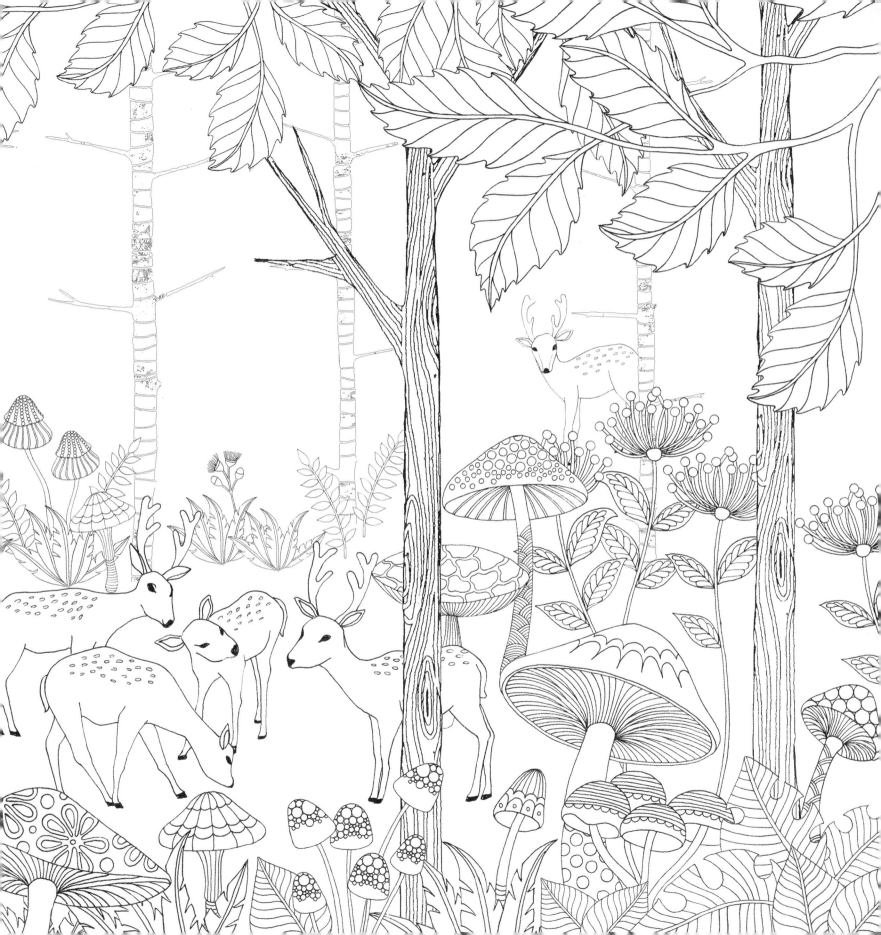

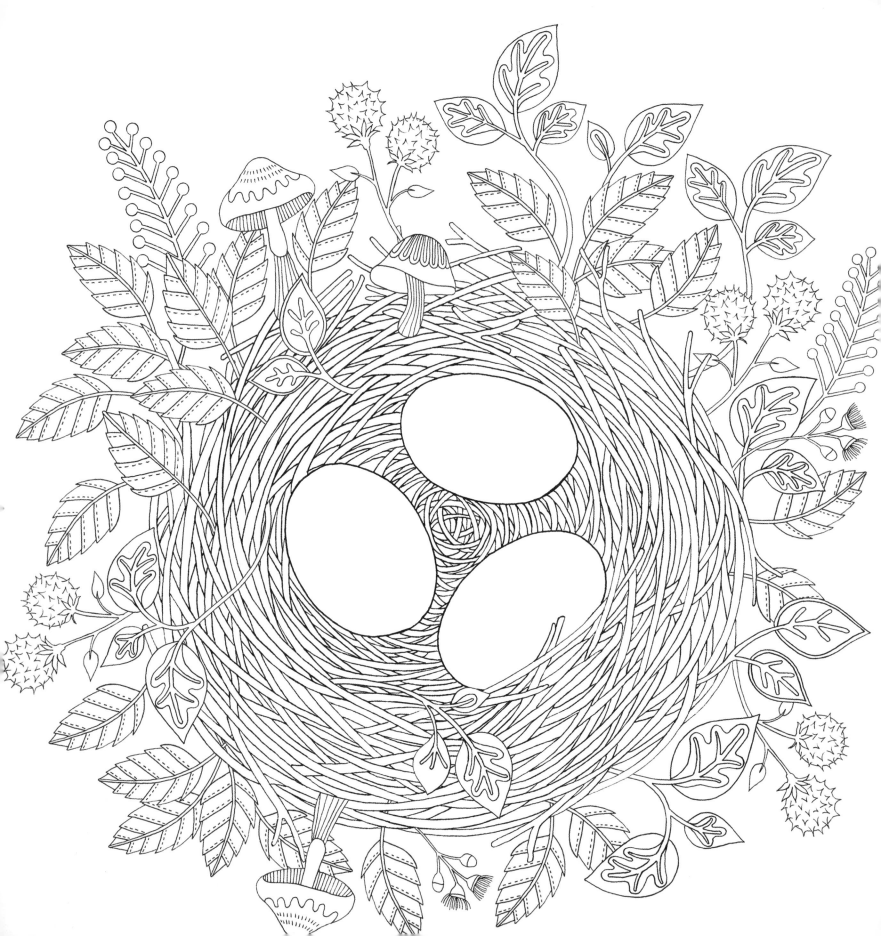

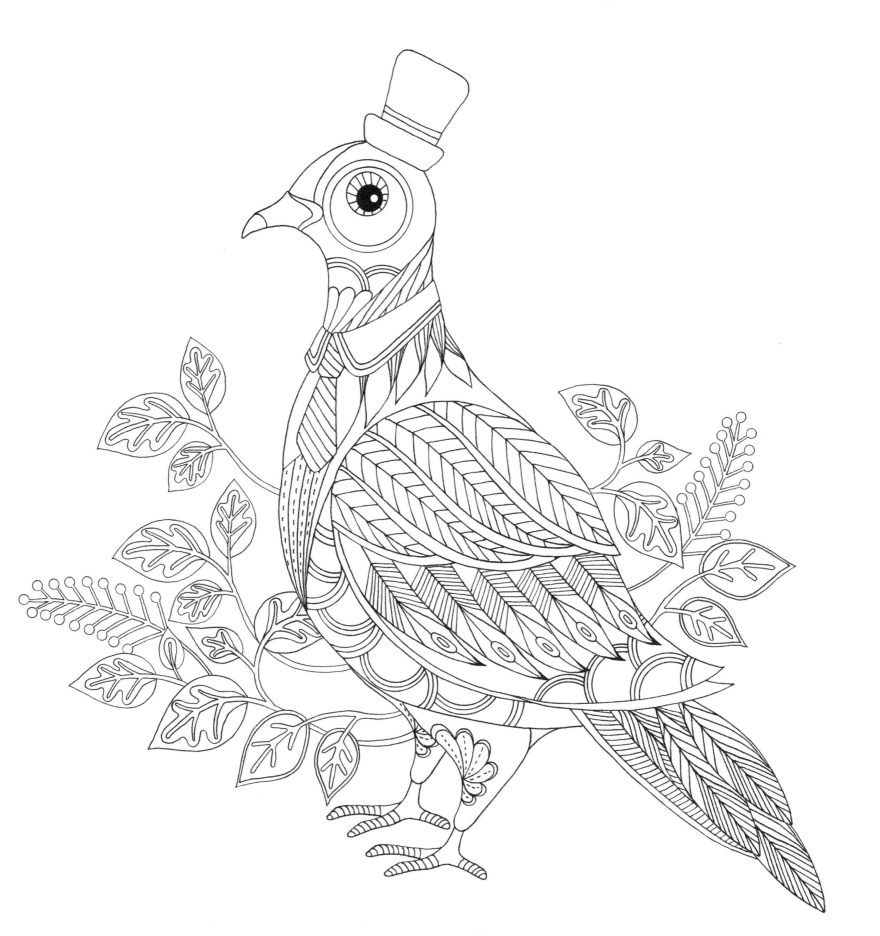

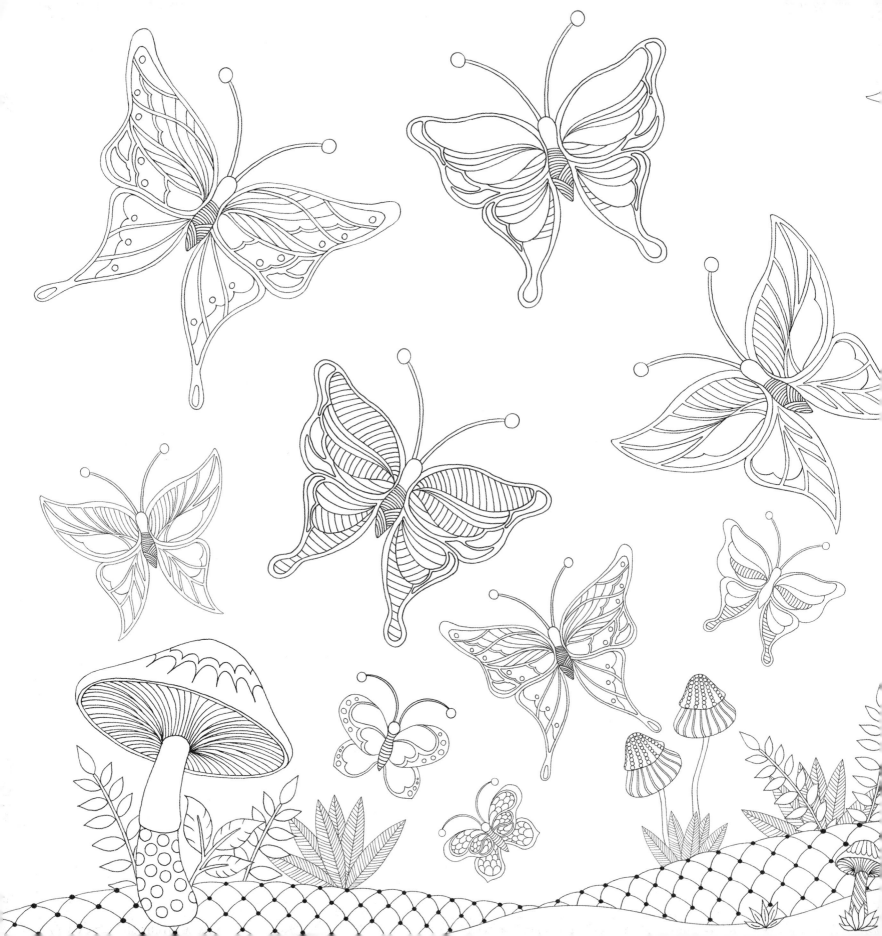

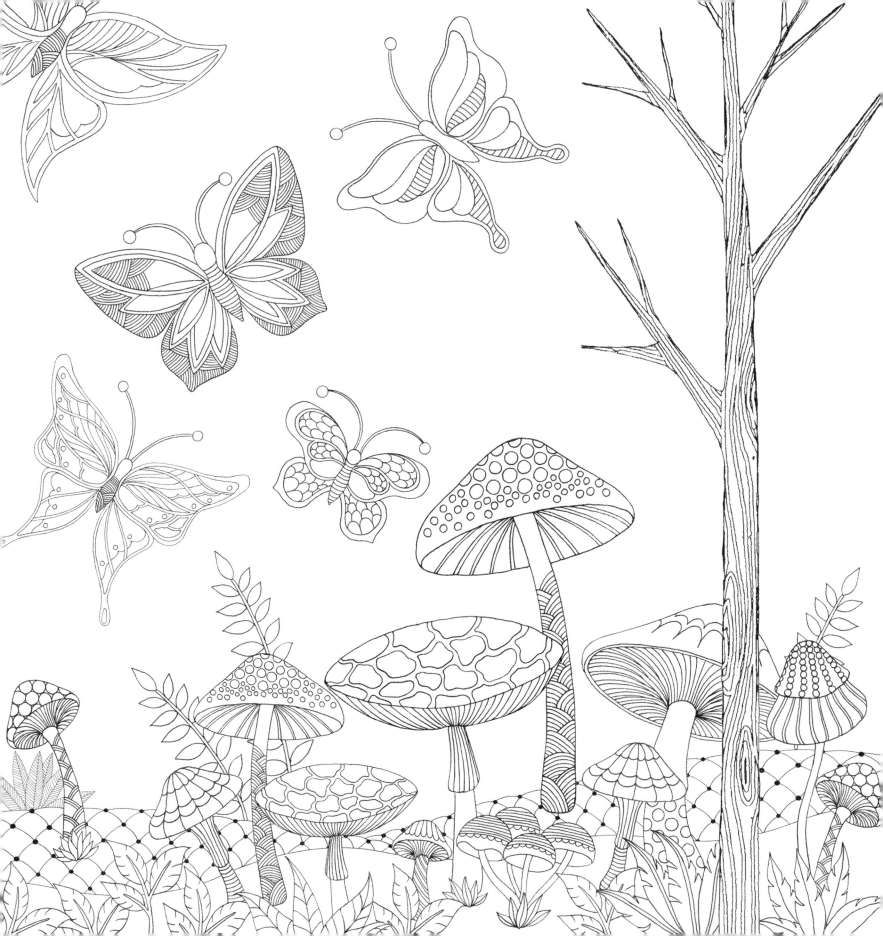

Give them some more beautiful butterfly friends!

6

A MAD TEA PARTY

I wander aimlessly, my feet aching, until I come to a garden. There I spot the March Hare and the Mad Hatter drinking afternoon tea. A Dormouse sits at the table, fast asleep.

March Hare and Mr. Hatter are talking in riddles. All day they drink and ask me to solve their impossible puzzles. With no time to clean cups, we swap places every hour, but I can't understand what they are talking about. Quite the stupidest party I've ever attended.

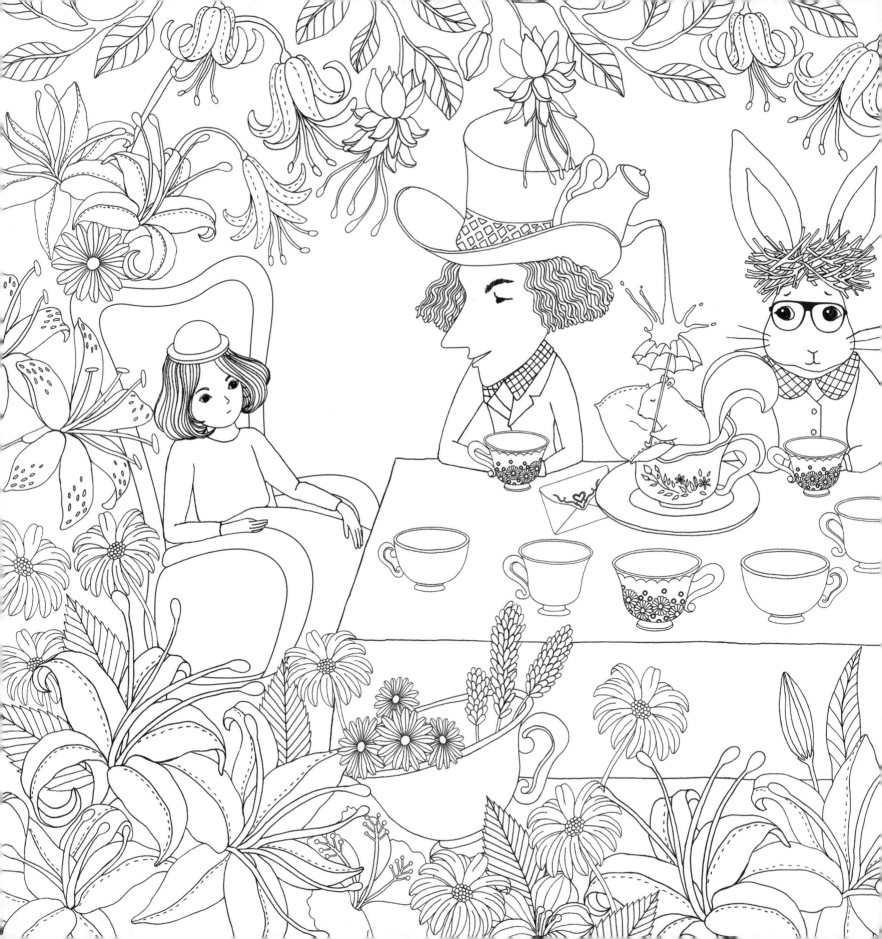

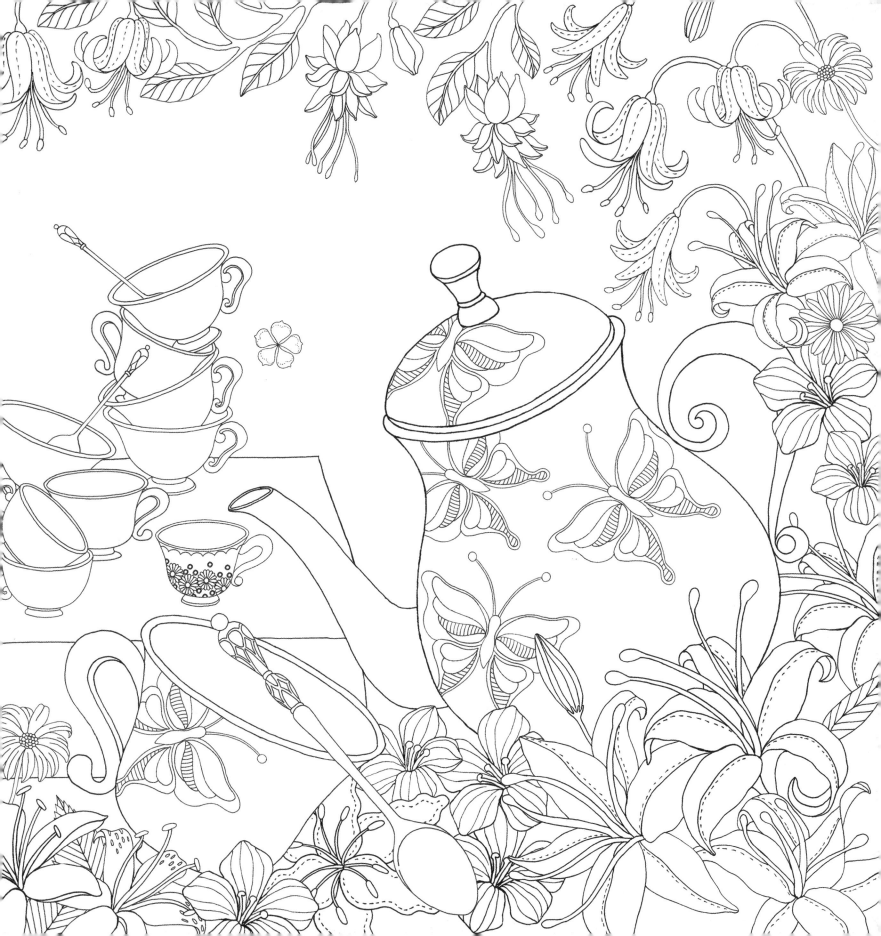

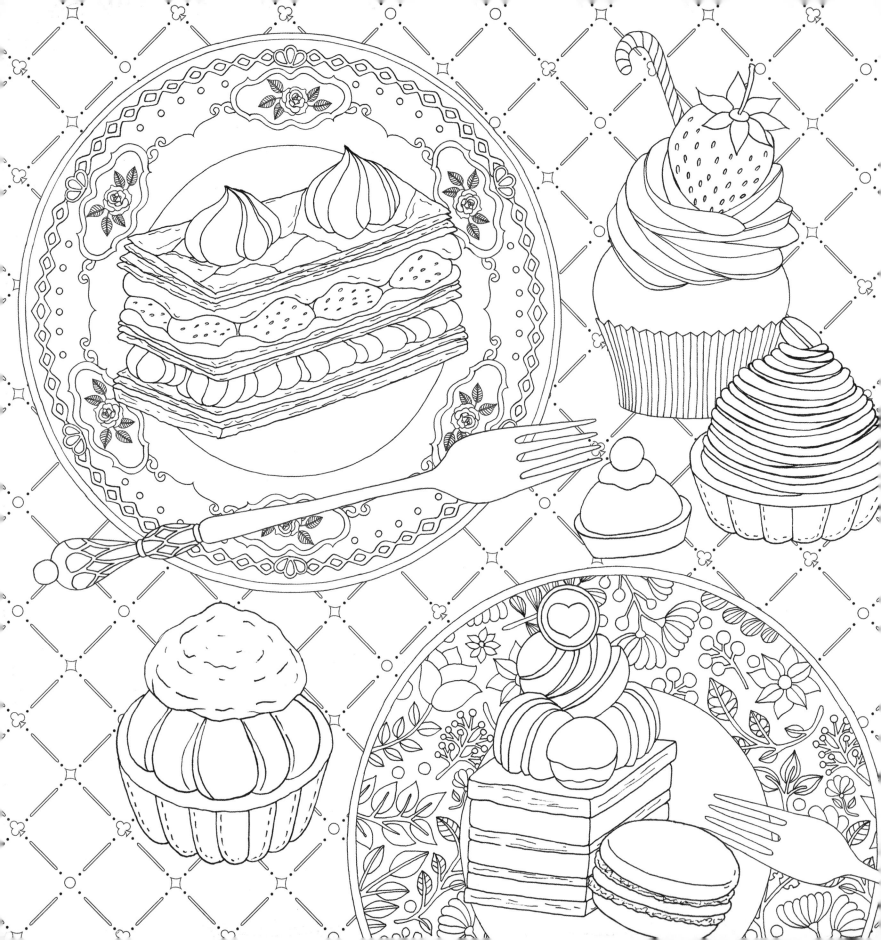

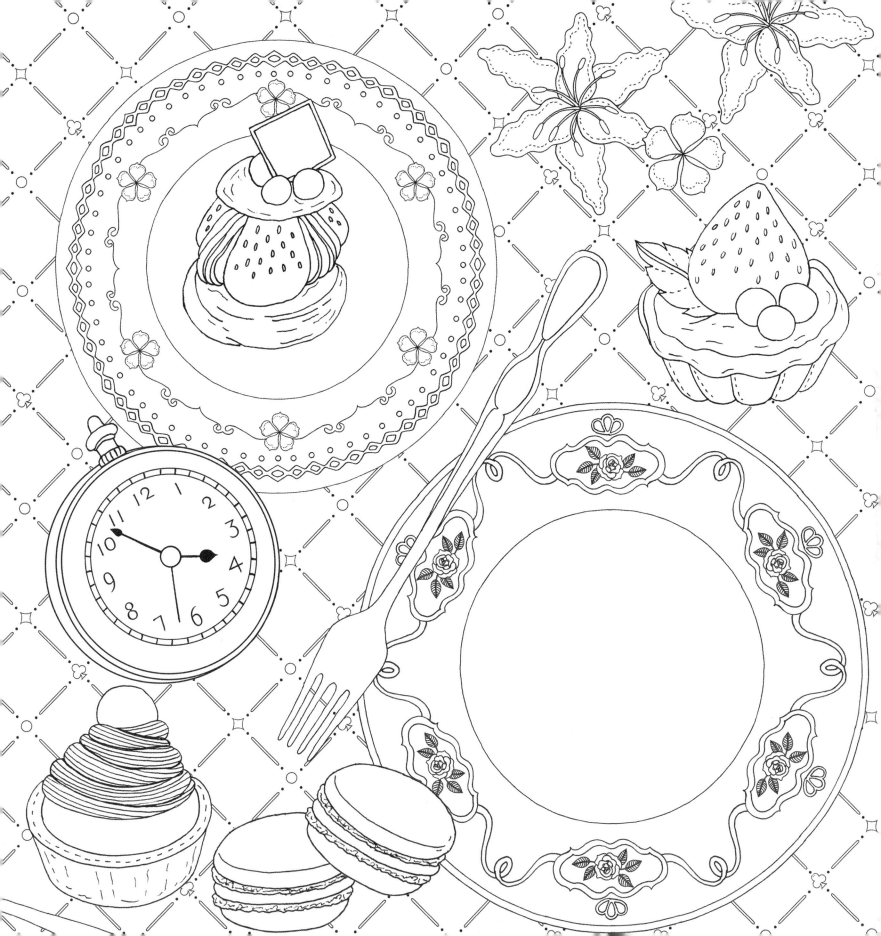

TO:

Is there someone you'd like to invite to join the party? Write their name here and start preparing the cakes!

7

AN INVITATION FROM THE QUEEN

A house appears up ahead. A Fish-Footman is out front knocking. Then a Frog-Footman opens the door.

The Fish-Footman is bearing an invitation: "The Queen invites the Duchess to play croquet." At this the Fish-Footman departs.

I sneak a look at the card to see when the game is to commence. At that moment, a grinning Cheshire Cat makes his appearance, yawns, and tells me the way. Just on the other side of Owl Forest, it seems.

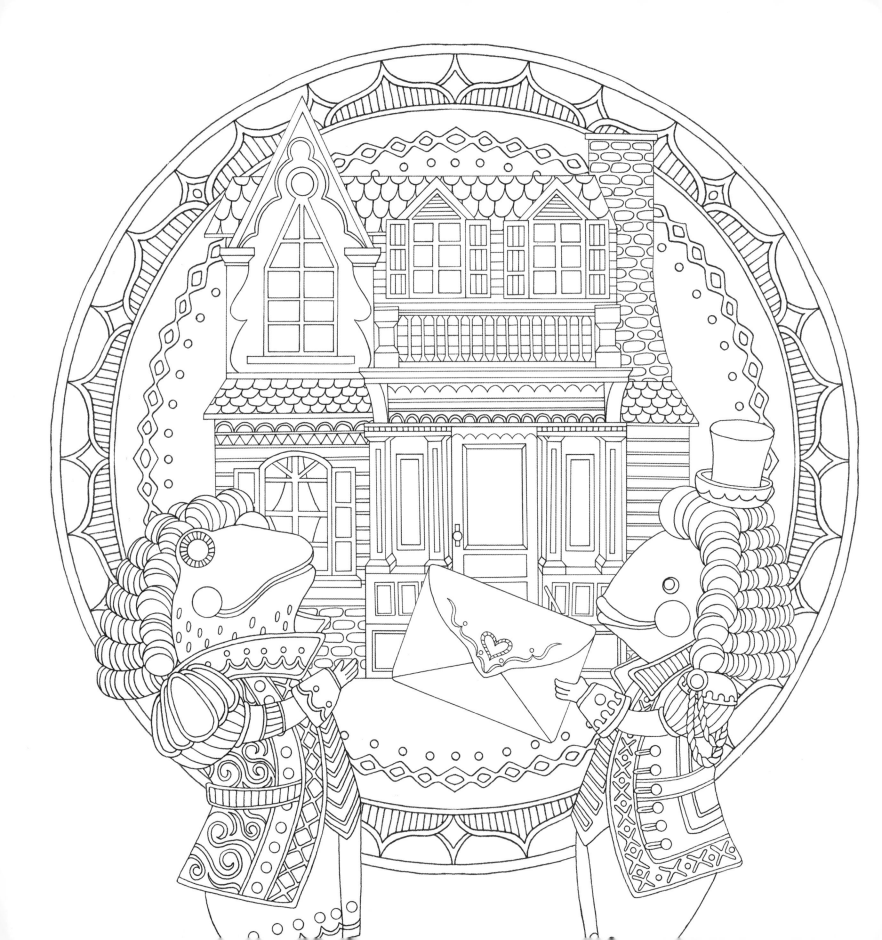

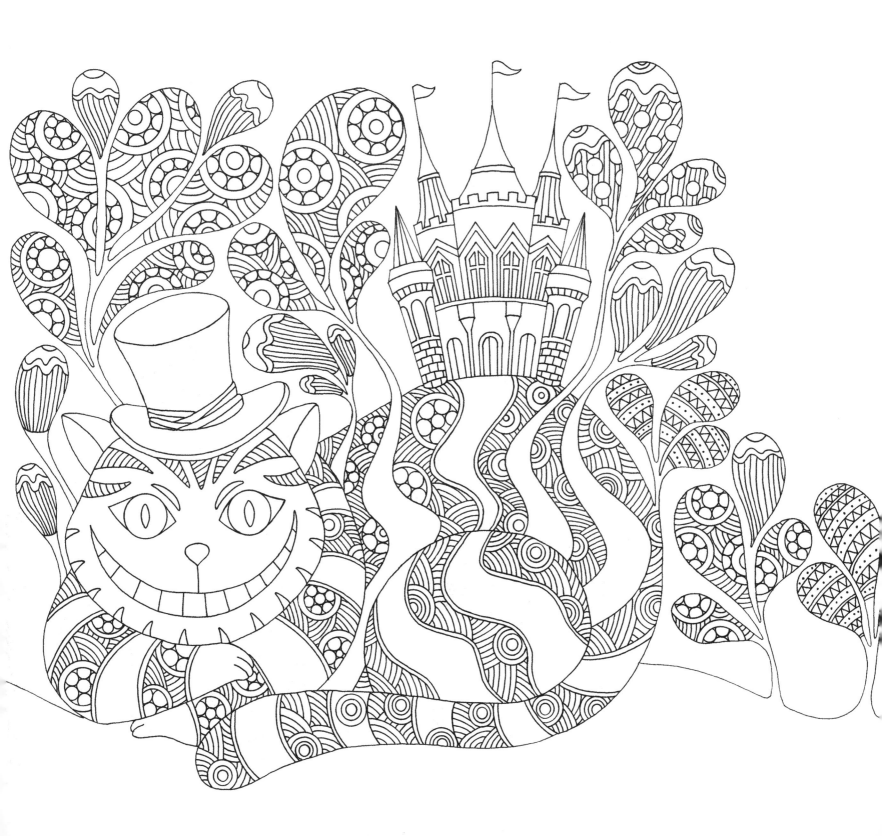

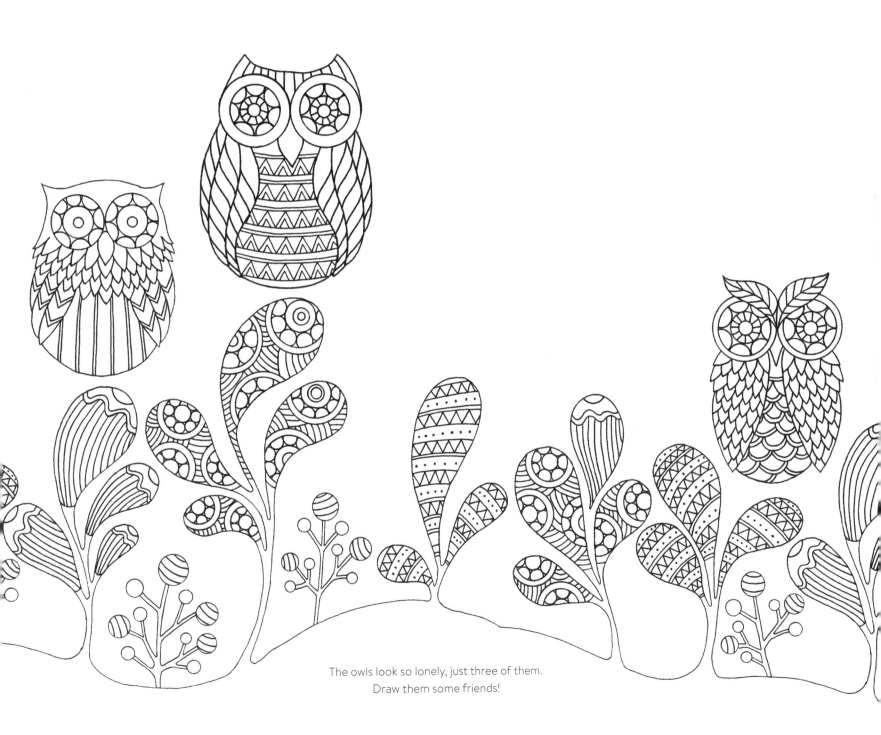

The owls look so lonely, just three of them.
Draw them some friends!

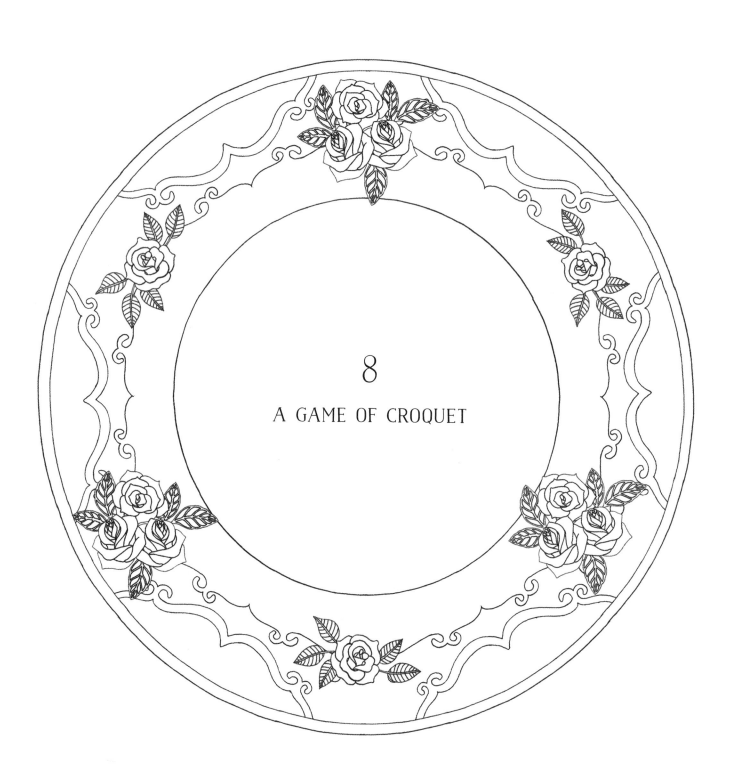

8

A GAME OF CROQUET

Finally, I arrive at the Palace with its garden of roses. The King and Queen draw up in their carriage, accompanied by a procession of Playing Card Guards lined up in formation. An extraordinary croquet match begins with flamingos as mallets, their necks twisting and turning, and hedgehogs as balls, rolling everywhere. How does one win this impossible game?

The Queen barks orders at her Playing Card Guards. One of them wears spotted trousers. And what about the flamingo's butterfly bowtie? Never mind, off with their heads!

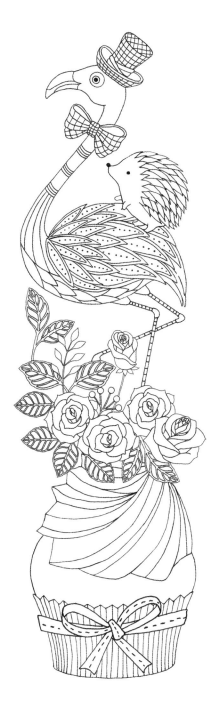

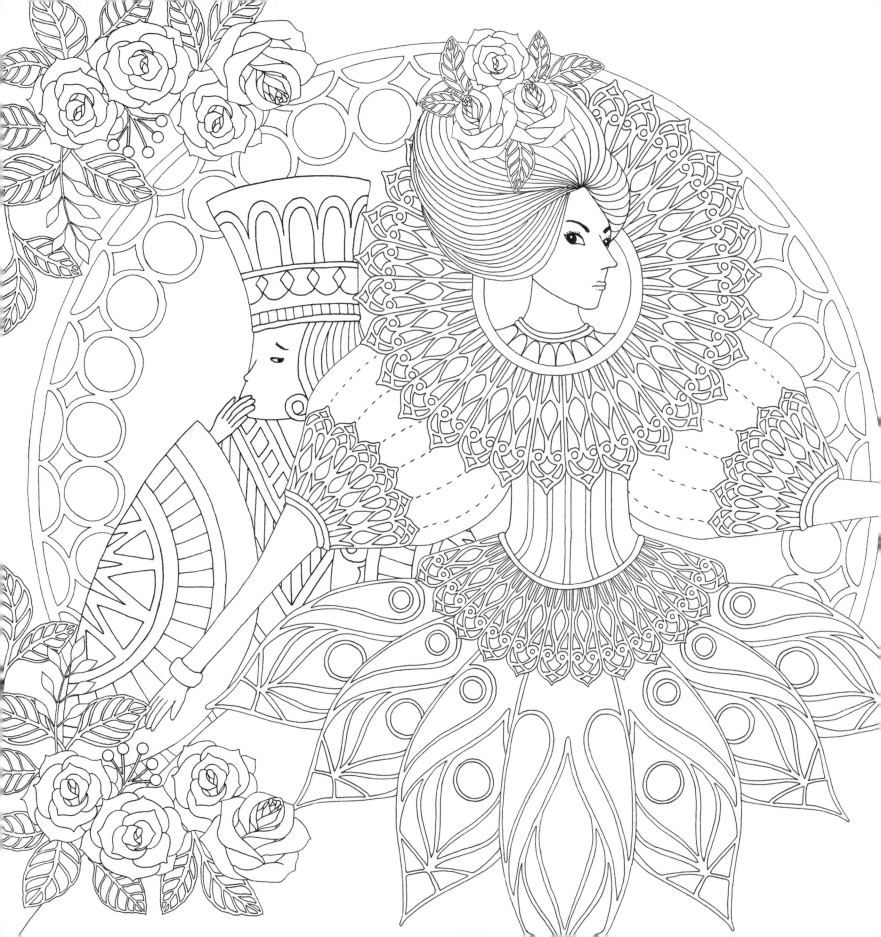

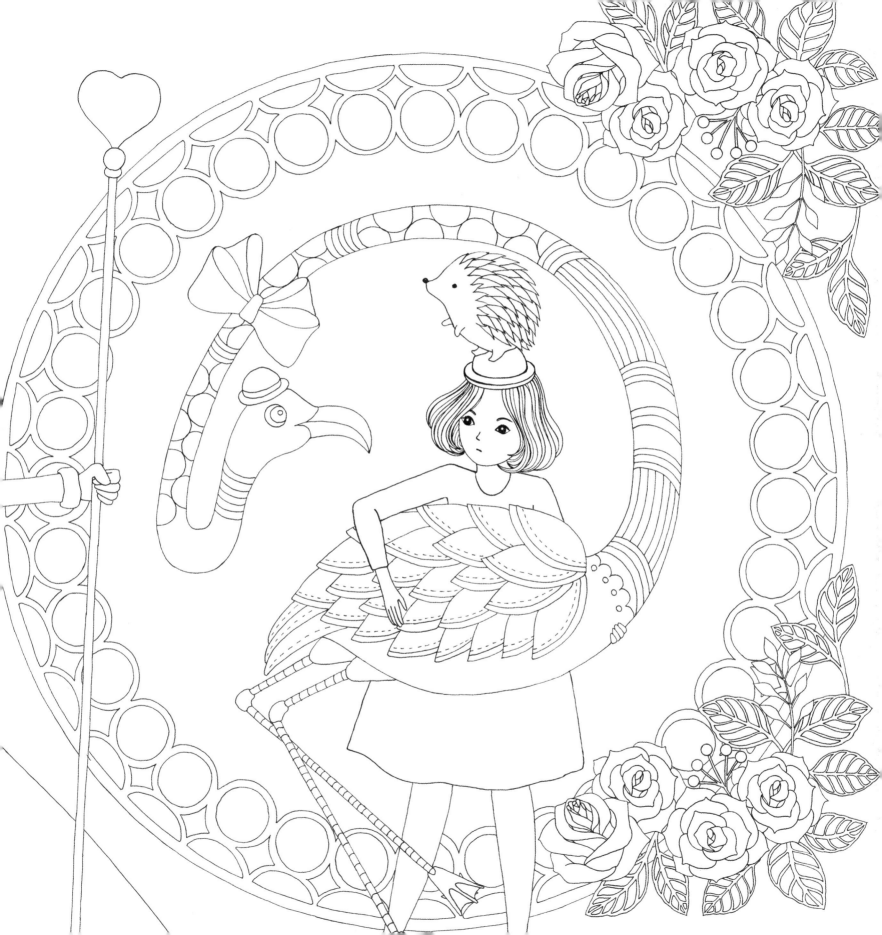

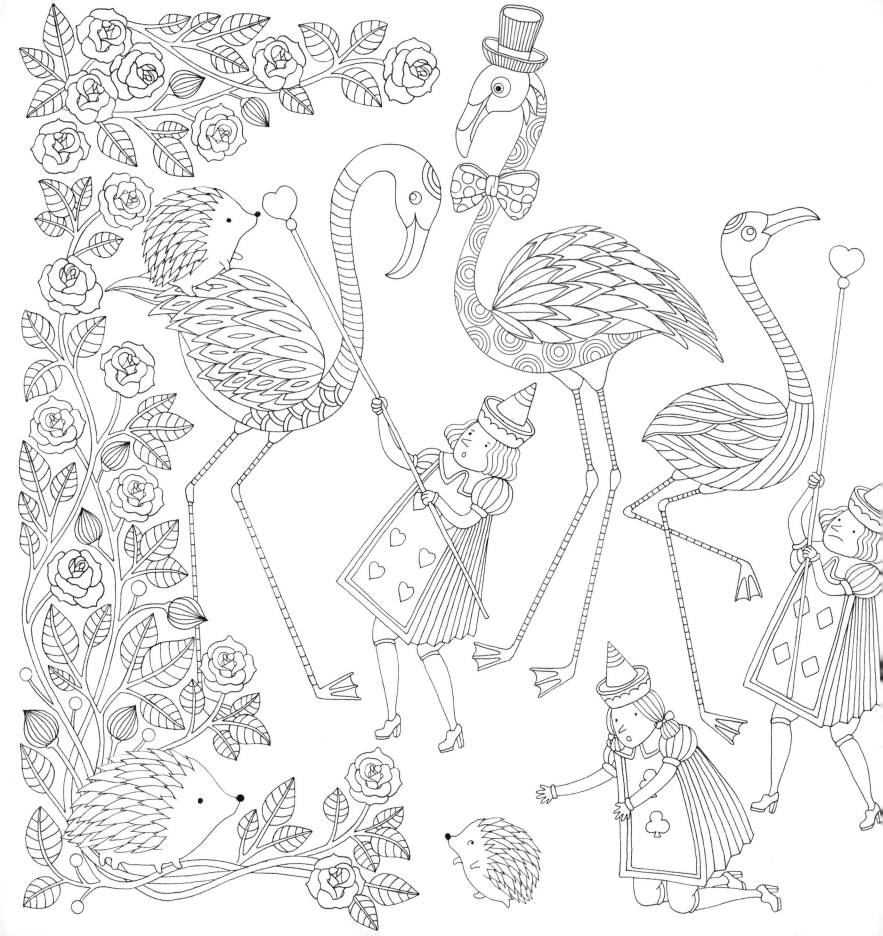

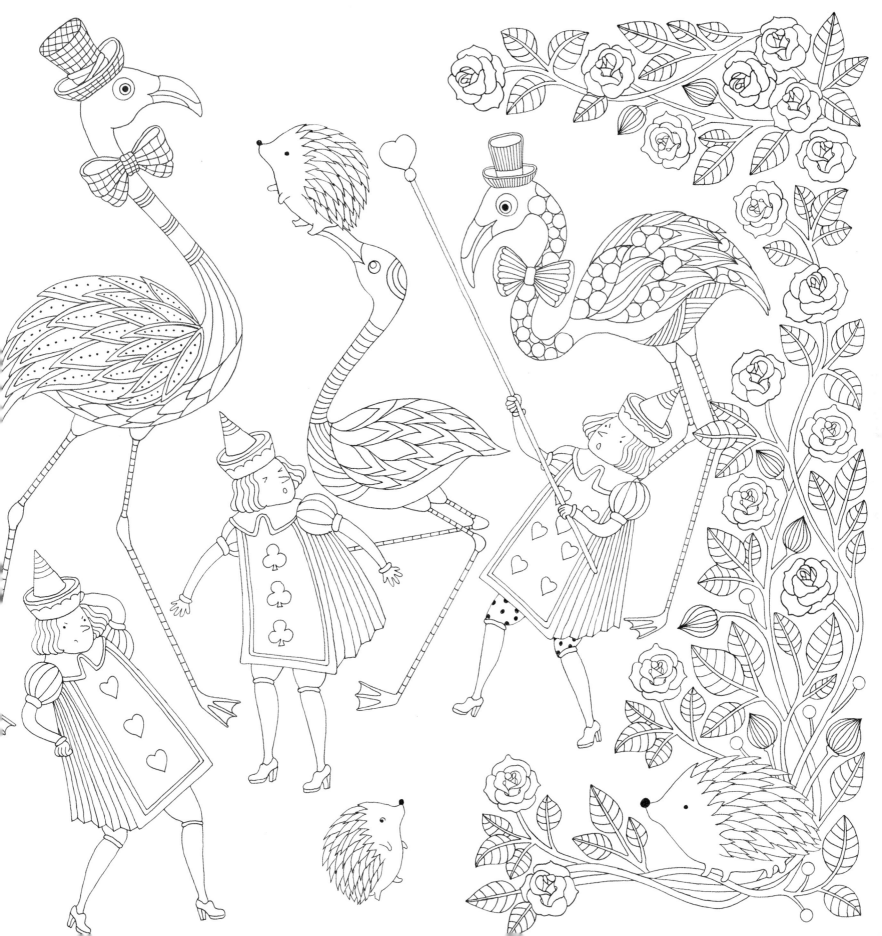

9

WHO STOLE THE TARTS?

The Queen demands, "Who ate the tarts?"
With no confession forthcoming, the trial
begins. An animal jury listens to evidence,
but the proceedings are unintelligible.

The Queen calls for the White Rabbit, who orders the
whole process to be photographed: "The culprit wears
stars on his clothes. She must know something!" The
White Rabbit points at me.

"Off with her head!" the Queen's words ring out.
Frightened, I run from the court and jump on a
carousel. My horse flies up into the sky. The pack of
cards chase after me, but are stuck, spinning around,
while I soar higher into the stars.

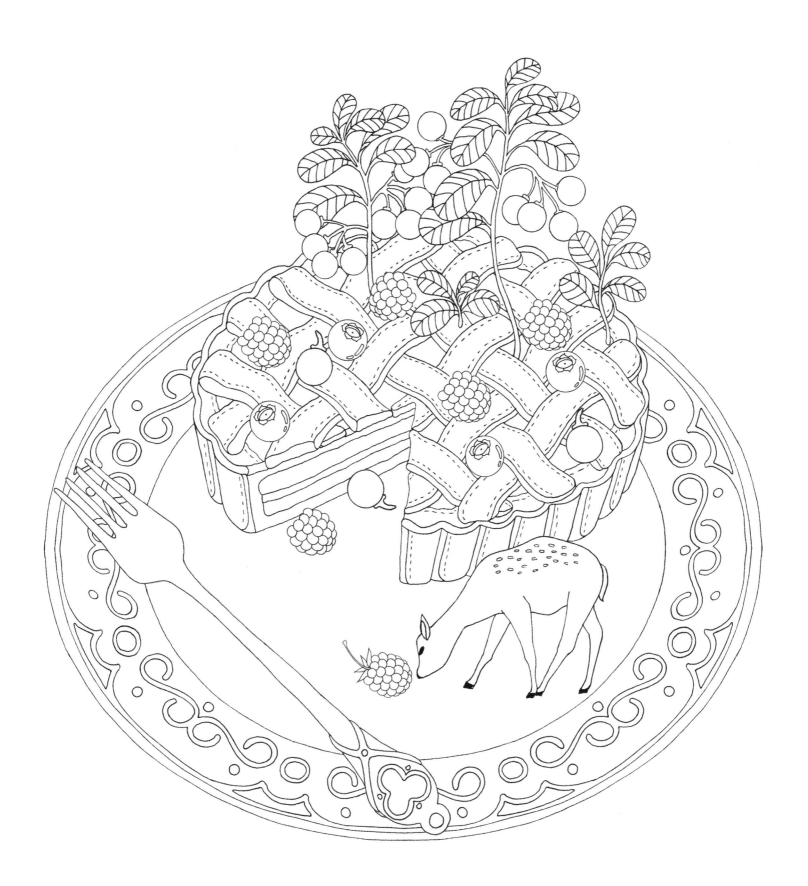

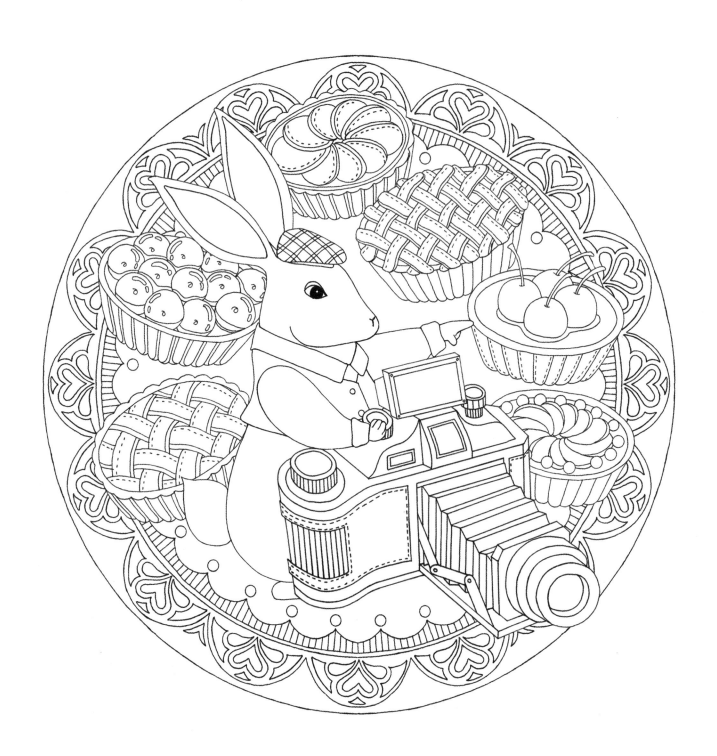

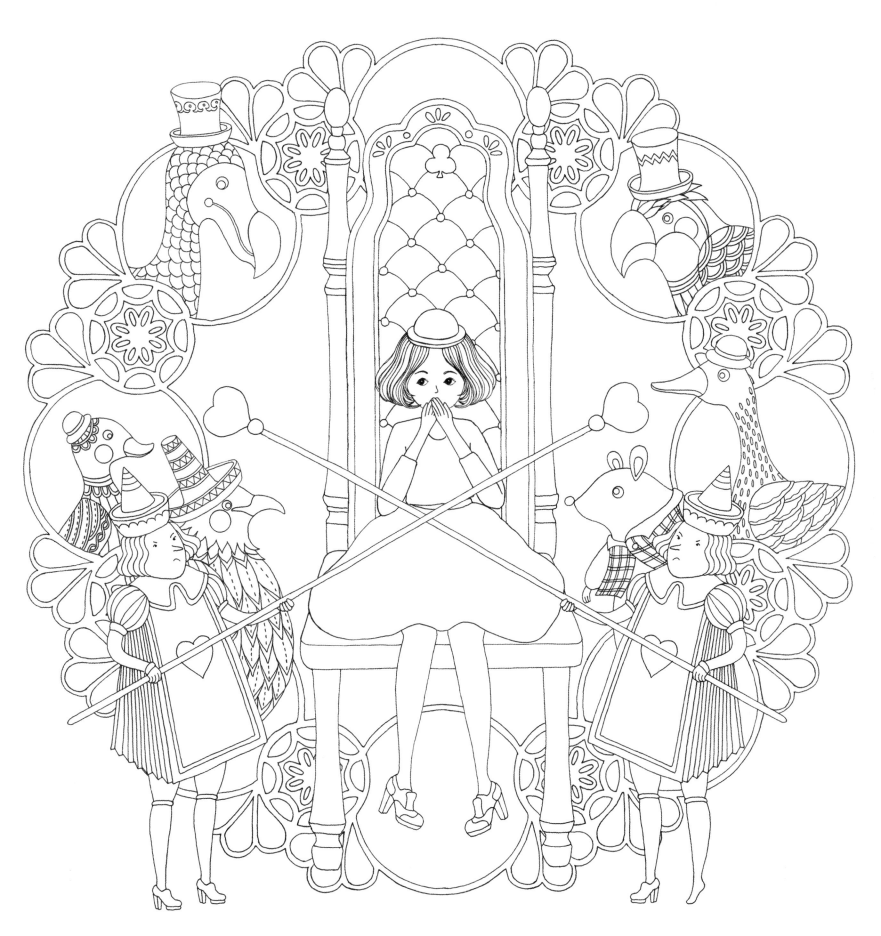

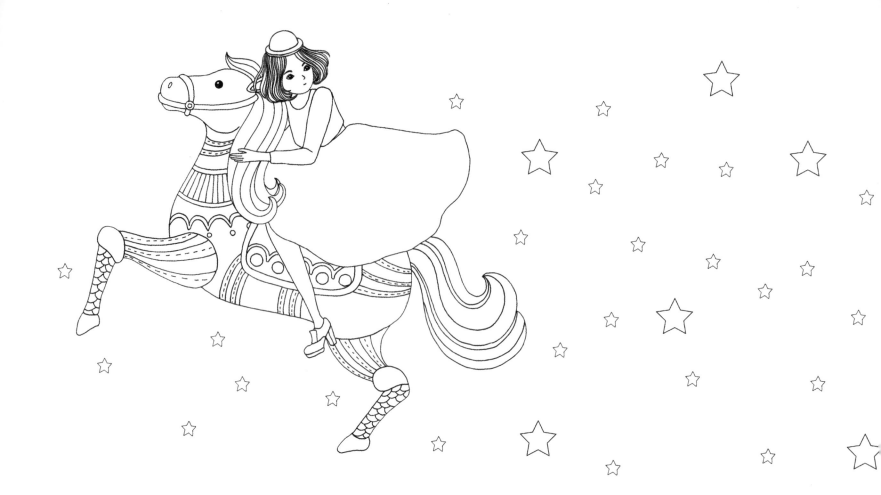

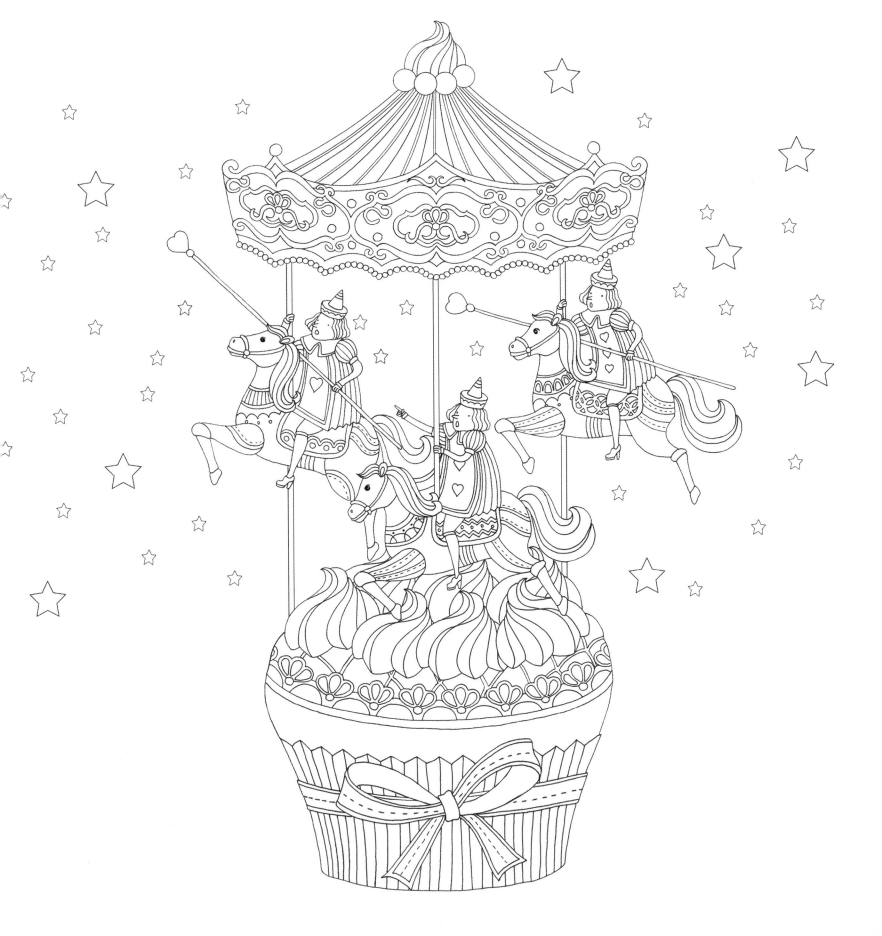

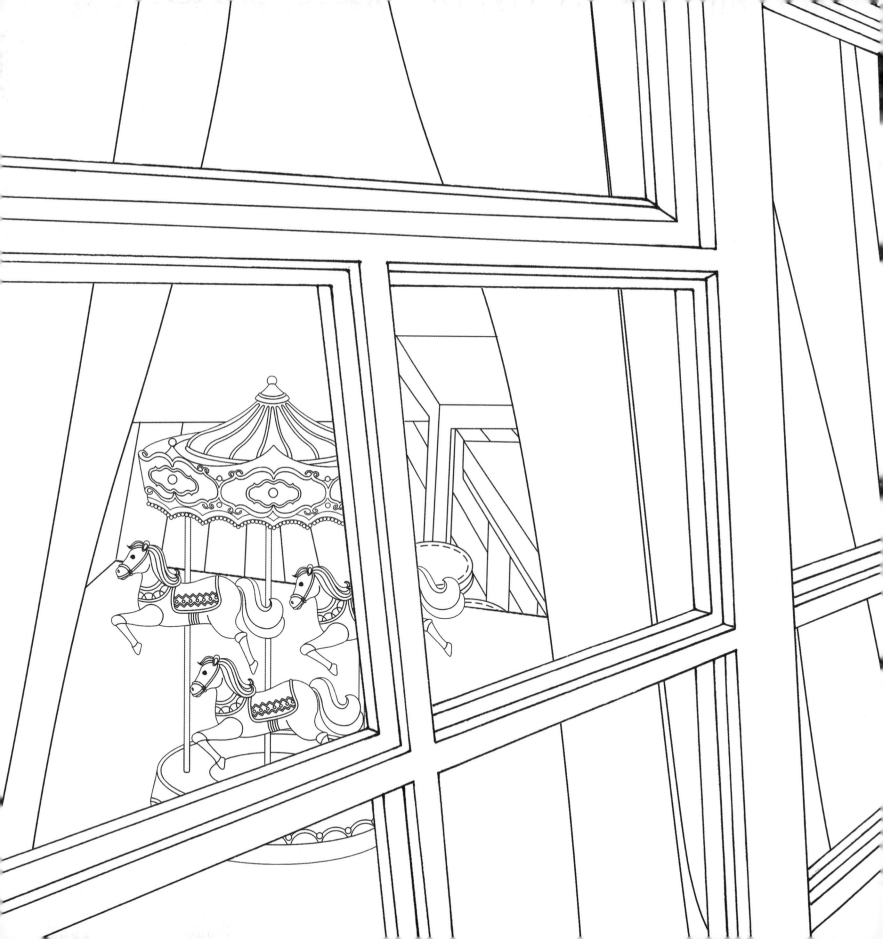

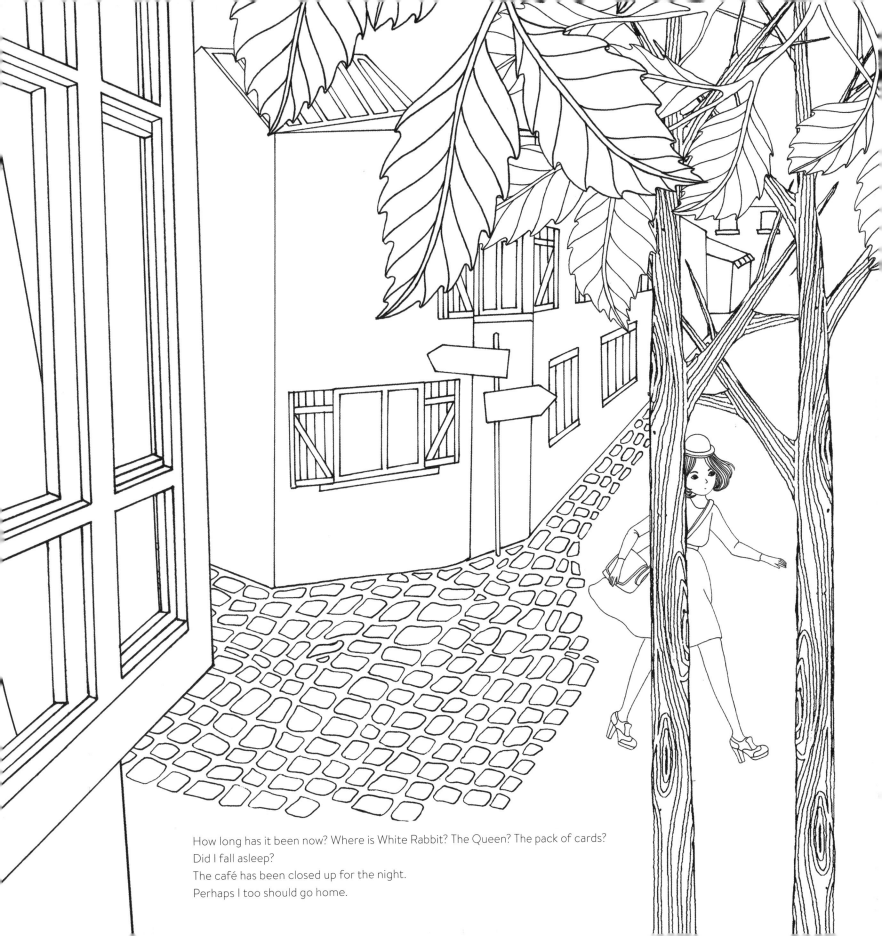

How long has it been now? Where is White Rabbit? The Queen? The pack of cards?

Did I fall asleep?

The café has been closed up for the night.

Perhaps I too should go home.

Is the tea party over?

THE END

ANSWER KEY

Question A:

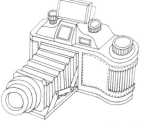

All the answers can be found in the White Rabbit's camera!

Question B:

Question C:

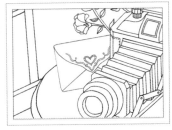 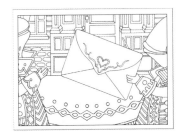

Question
D:

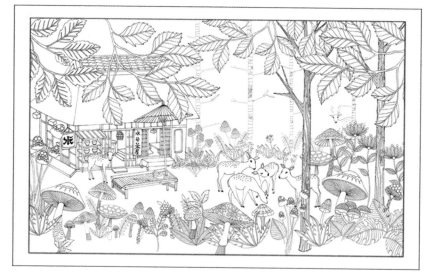

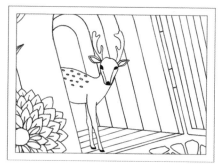

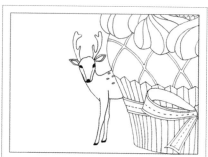

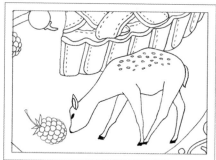

Question E: The playing card
dressed in stars!

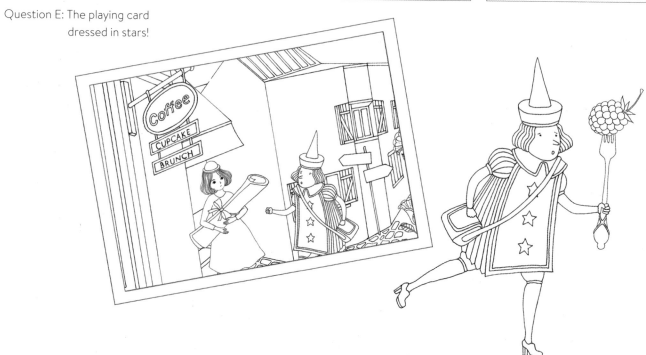